DIDCOT
THROUGH TIME
Brian Lingham

AMBERLEY PUBLISHING

This book is dedicated to my wife Barbara, who has enriched my life

First published 2014

Amberley Publishing
The Hill, Stroud, Gloucestershire, GL5 4EP
www.amberley-books.com

Copyright © Brian Lingham, 2014

The right of Brian Lingham to be identified as the
Author of this work has been asserted in accordance with
the Copyrights, Designs and Patents Act 1988.

ISBN 978 1 4456 3588 0 (print)
ISBN 978 1 4456 3604 7 (ebook)

British Library Cataloguing in Publication Data.
A catalogue record for this book is available from the
British Library.

Typesetting by Amberley Publishing.
Printed in Great Britain.

Introduction

The aim of *Didcot Through Time* is to show how change has affected Didcot over the past 100 years or so. Many old postcards and photographs dating back to the 1900s of the old village of Didcot, the railway, Broadway and other parts of the town have been reproduced with modern photographs taken to show, by comparison, how those changes (if there are any) have affected the town. In many instances, of course, it might be said that there has been only superficial change.

It was not until I started to produce the modern comparable photographs that I realised the dramatic impact the motor car has had on the landscape of Didcot. I found it very difficult to take photographs without streams of motor cars obscuring the view, so much so that it became easier to photograph on Sundays. Everywhere you turn, the car is there, either parked or moving on the road – though I hasten to add that I am a motorist myself! Nevertheless, their presence made it difficult to reproduce the photographs of the past exactly. I could hardly stand in the middle of the road as the earlier photographers obviously did – being more prudent, I elected to stand on the pavement. Today's roads have pavements, giving a delineation that former roads did not have, which seemed to add to their charm.

However, change and Didcot are practically synonymous; the town has been subjected to growth ever since the Second World War, increasing in size and population as housing estate after housing estate was added to the town. By the middle of the twenty-first century, Didcot is expected to become the largest town in South Oxfordshire, its suburbs sprawling out to engulf surrounding villages, much to the horror and apprehension of the villagers.

Although the modern town can only date its present-day growth from 1844, when the railway station was sited at Didcot, the town has a long history. It is of far greater antiquity than many of the nearby villages, dating back to the Bronze Age.

It was the decision of one man in the nineteenth century that transformed Didcot, which was then a sleepy village smaller than Appleford, into the modern town of today. That man was Isambard Kingdom Brunel, who laid down the Great Western Railway (GWR)

through Didcot and on to Swindon in 1839. It was a further decision of his that sealed Didcot's fate irrevocably, when he sited the railway station in the parish to act as a terminus for the line to Oxford.

The siting of the station brought a new breed of working men to Didcot, the railwaymen, who needed housing. They did find homes in the villages but more were needed, and to this end Stephen Dixon, an East Hagbourne farmer, began erecting houses in what became known as Didcot New Town or North Hagbourne (now known as Northbourne).

By their very presence, the railwaymen unwittingly brought about ill feeling and resentment locally. This was because they were well paid and free of control by squire and parson, and as a consequence were hated by the farm labouring families of the local villages, who, by contrast, were poorly paid, lived in tied housing and were subject to the whims of their 'betters'. This dislike was shared by all classes for differing reasons. The ill feeling between the railwaymen and the villagers persisted as late as the 1960s, and only then did it start to dissipate.

The next event was the decision by the Army in 1915 to site an Ordnance Depot at Durnells Farm, near to the railway, as Didcot was a major railway junction. The Army needed to relocate because the Woolwich Arsenal was too vulnerable to attack from both air and sea. Because of initial construction problems, the Army had to appeal for volunteers, who assisted in making the depot operational, and by 1916 the new depot was supplying the Army in France. The Army also had other problems when the workers it attracted needed housing, and although they did build some houses, the majority were provided by private enterprise in the estates of the 1920s and '30s.

The Second World War brought new pressures on the Ordnance Depot, which had expanded enormously, bringing even more workers to Didcot. By 1945, Didcot was bulging at the seams with people, evacuees, depot workers and the military, and consequently demand for housing was high. Housing was provided in the form of housing estates, which were built during the post-war years, from the 1940s to the 1960s.

For many years, another dominant feature of Didcot was the power station, which was constructed in the 1960s and opened in 1971. After forty years of generation, it closed down in 2012. It, too, attracted new workers with a need for housing, which was satisfied by the housebuilding of the 1960s.

In 1979, Didcot was selected by the South Oxfordshire District Council as the major growth area for South Oxfordshire. Consequently, more than 9,000 houses are to be built in the coming decades and the population is expected to reach at least 30,000 by 2016. The Orchard Shopping Centre was built to service this extra population and is due to be extended in the coming decade. The future for Didcot is bright.

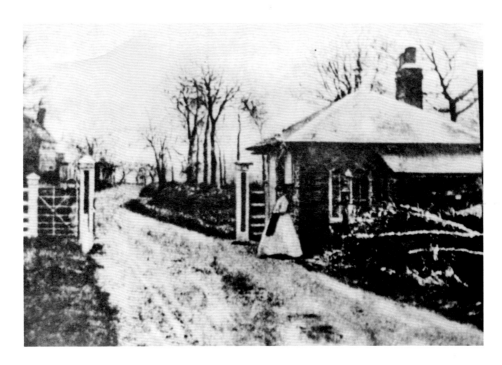

The Wantage Road Toll Gate, *c.* 1870

This is the earliest known Didcot photograph. It shows Miss Bessie Lovelock, standing in front of the Dudcote toll gate on the Wallingford–Faringdon Turnpike Road in around 1870. The Turnpike Trust, which maintained the toll road and fixed the tolls, had been set up by the local gentry and landowners of North Berkshire in 1752. There were three toll gates in Didcot: this one in Wantage Road and two others at the top of Park Road and at Hagbourne Road. The Turnpike Trust was abolished around 1879, and the toll gates pulled down afterwards. The houses that now stand on either side of Wantage Road were built in the 1920s and '30s.

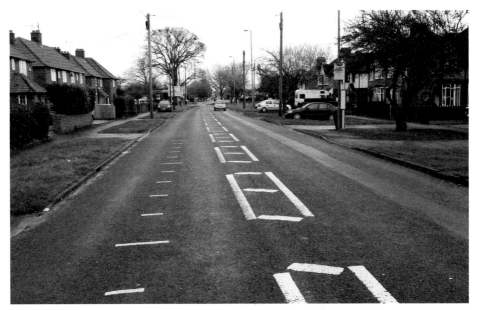

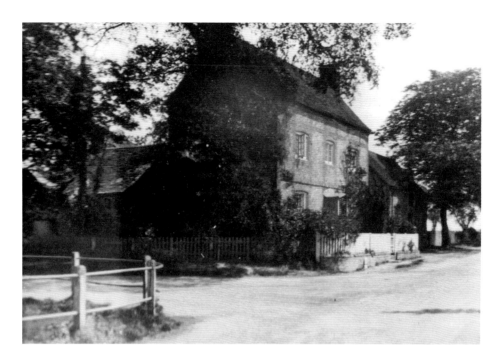

New House, *c.* 1920

This is (or was) New House, which formerly stood at the corner of Broadway and Foxhall Road. The house was built in 1783, by the then Lord of the Manor, John Baker, as the farmhouse of a small farm of some 30 acres, most of which lay in East Hagbourne. Up to 1929, the house was occupied by George Davis, who died that year. The corner by the house was known as 'Davis' Corner', and when George Bowering purchased the house in the 1930, it became 'Bowering's Corner'. It was Bowering who turned the house into a petrol station.

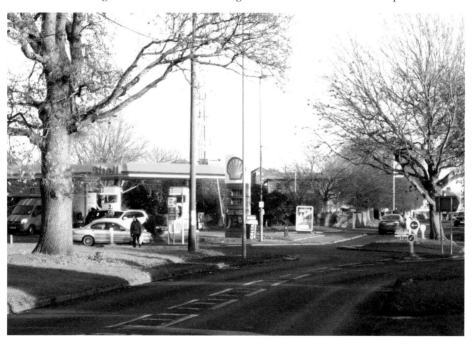

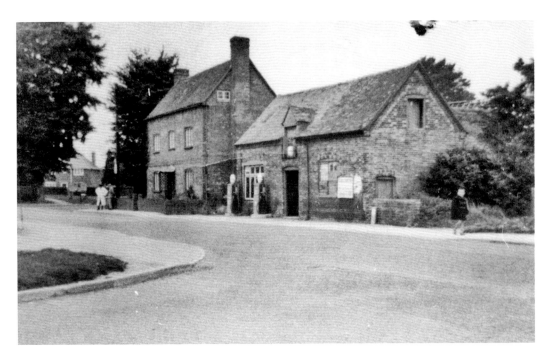

New House, *c.* 1950

The house continued as a petrol station until Bowering's death in 1960, when his family sold the property to Shell, who demolished the old house to replace it with the modern petrol station, as seen below. It is an illustration of the way attitudes have changed. In 1960, when the house was pulled down, there were no protests from anyone at the destruction of this late Georgian house, despite it being the only example to have been built in Didcot. Today, it would be a different story, but there was no real interest in vernacular buildings back then.

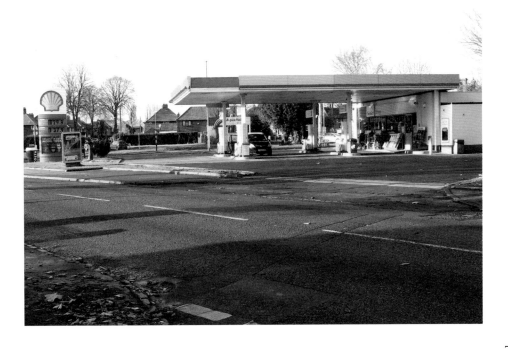

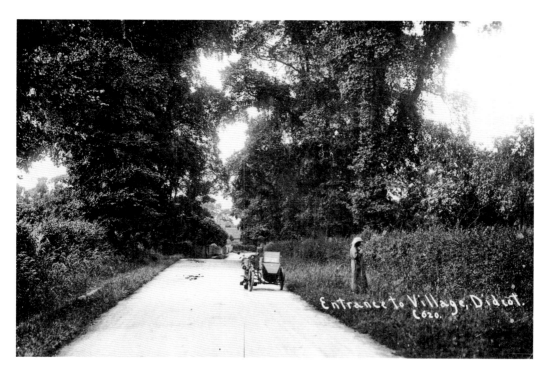

Foxhall Road, *c.* 1915

This pretty, tree-lined country lane was Foxhall Road, sometime before 1925. These great elms were removed when the houses now lining the road on either side were built. Before the Second World War, the road was known as Vauxhall Lane or Road; it was changed in 1946 to 'Foxhall', the proper spelling. The difference was due to the Berkshire dialect, which pronounced an 'F' as 'V', so 'Foxhall' became 'Vauxhall'. However, the Army still kept the old spelling, hence Vauxhall Barracks.

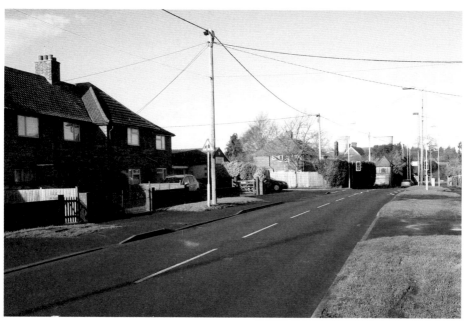

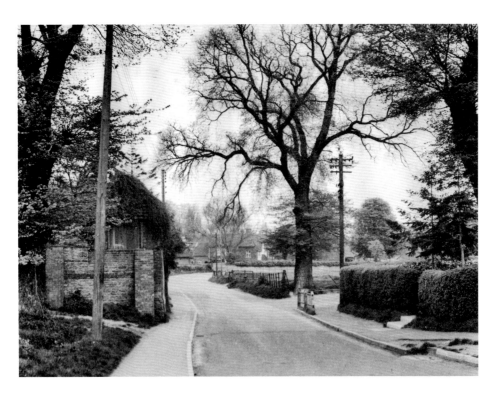

Entrance to the Village of Didcot, c. 1951
This really was the entrance to the village, or at least it was at the time this photograph was taken. On the left is the summer house of Manor Farm, which is quite an old feature, having been built by the Blake family, then lords of the manor, before 1783. It formed part of the garden of Manor Farm. The large field beyond the tree is now occupied by a detached house. In the far distance, Smiths Farm can be seen.

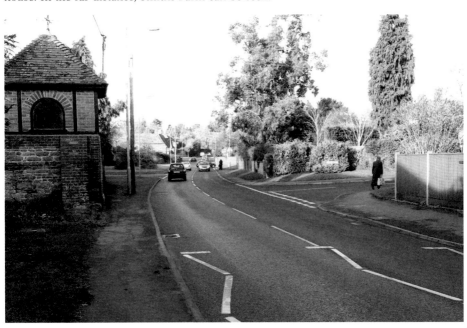

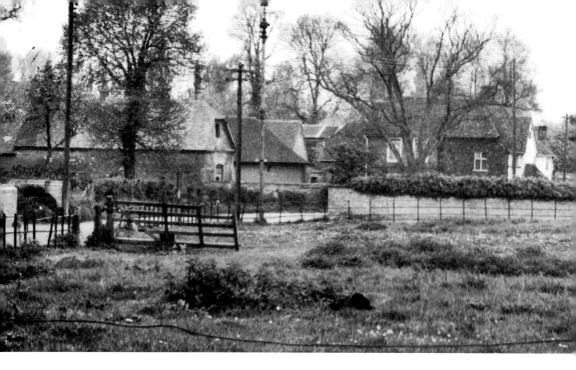

Smiths Farm, *c.* 1951
Smiths Farm and its barns in Foxhall Road, before the road was straightened, and before the modern house was built on the field in the foreground. The barns that were still there in the mid-1970s have now nearly all gone, as have the many trees. It was still very rural, considering the date of the photograph (around 1951).

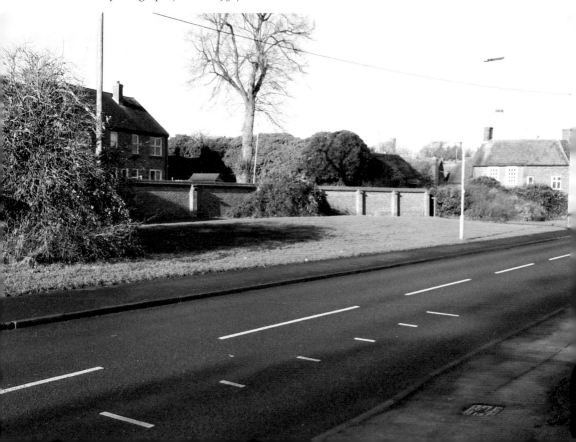

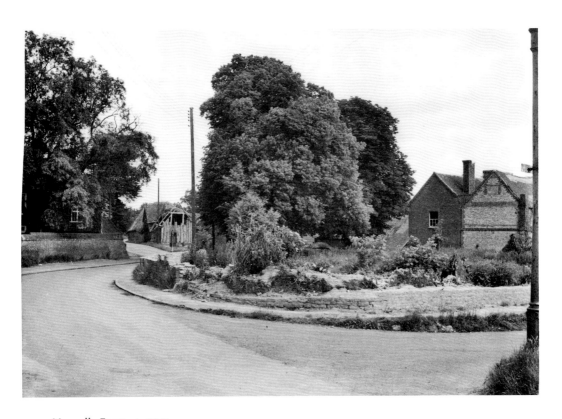

Morrells Farm, *c.* 1951
Further up Foxhall Road, again around 1951. On the right is the farmhouse of Morrells Farm, which dates from the seventeenth and eighteenth centuries. By this time, the house was in poor condition and the local authority forced its demolition as it was unfit for human inhabitation. A new bungalow was built in its place.

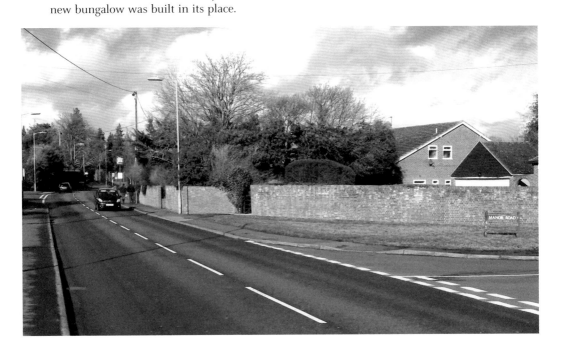

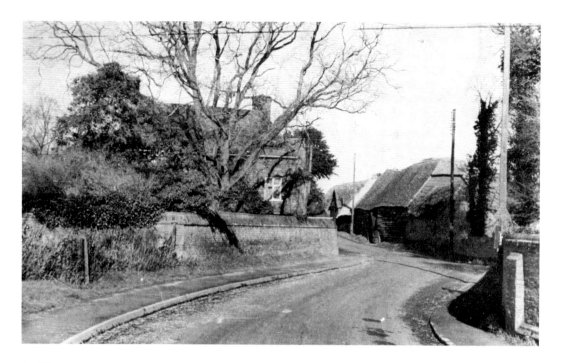

Smiths Farm, c. 1939

For centuries, Foxhall Road had been a twisty, meandering lane, before it was straightened by the county council in 1953. On the left-hand side is Smiths Farm. Opposite are the barns of Morrells Farm. These were removed at the end of the 1940s, though the Great Barn became the Conservative Club, which is still there today. The large tree in the garden of Smiths Farm was thought to be a honey locust and was felled many years ago. There was, momentarily, a great deal of excitement in 1951 when it was suggested that it was a holy thorn, of which there were only two others in the country, one at Glastonbury and the other in Herefordshire.

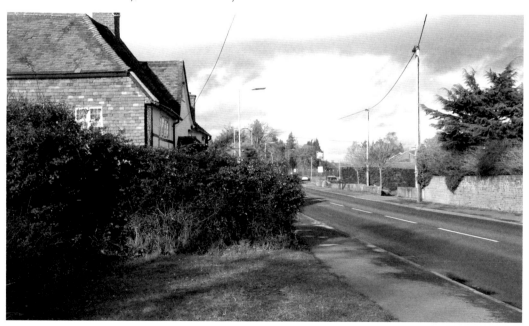

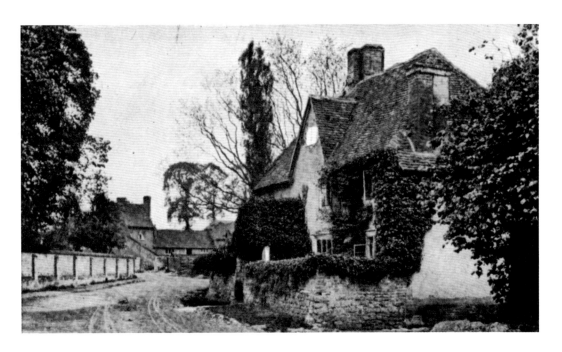

Smiths Farm and Manor Farm, *c.* 1905
Smiths Farmhouse, on the right, was built around 1632 by William Taylor. The house and farm continued in the family's ownership until 1869, when the farm was sold. Henry Smith was the new tenant. The Smiths eventually bought the farm, and although they sold it to the Ryman family in 1935, the farm continues to be known as Smiths Farm. The buildings in the middle foreground are those of Manor Farm, dating to the mid-seventeenth century.

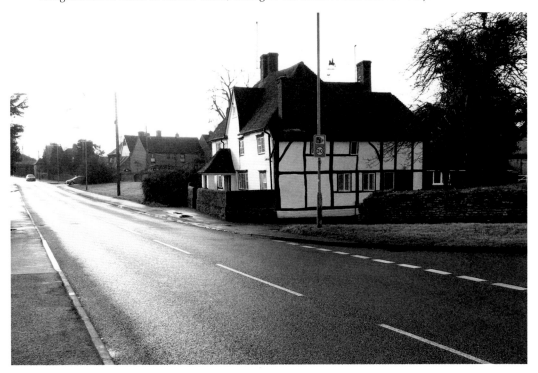

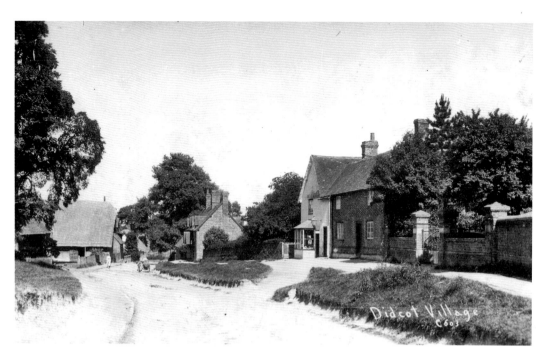

Manor Road, c. 1915

Manor Road (or High Street, as it was previously known) is shown during the First World War; it was renamed in 1929. On the right, the village shop can be seen, which was the mainstay – and the centre – of the village until the arrival of the new shops in the 1930s. Broadway Shopping Centre caused it to close. The house dates to 1672. On the whole, not much has changed since then.

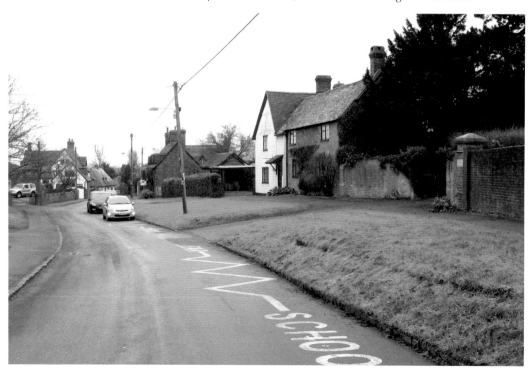

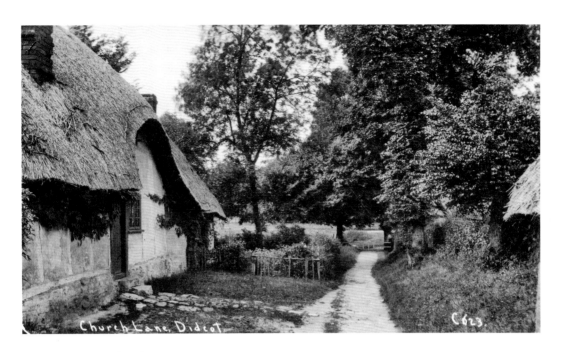

The Nook, Church Lane, c. 1915

The Nook, a mid-sixteenth-century cottage, was built by the Boulter family around 1550. It was enlarged by them, bay by bay, early into the seventeenth century. By the eighteenth century, it had been split into three tenements, housing three families. This was still the case when the postcard above was issued. It was not until after the First World War that the cottage was owned and occupied by one family, as it is today.

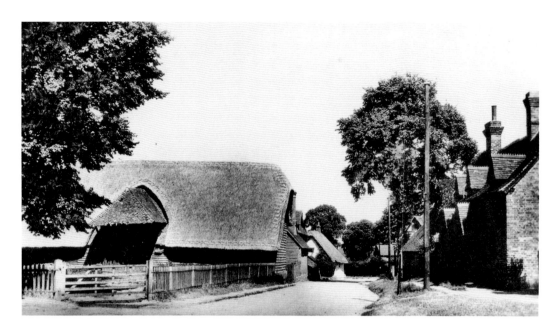

The Barn, Manor Road, c. 1931

This large barn was formerly part of the farm attached to No. 30 Manor Road. It was destroyed by fire in 1940, which was said to have been caused by a courting couple who dropped a match. When he saw the destruction and that many of his animals had been killed by the fire, the farmer dropped dead with shock. A bungalow, built by Tom Tappin of Tappins Coaches, now stands in its place. At one time, there were four large barns in the village, but all have now gone – either pulled down or destroyed by fire – apart from the one, which now houses the Conservative Club.

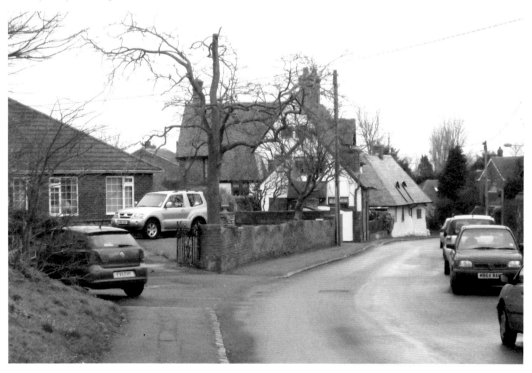

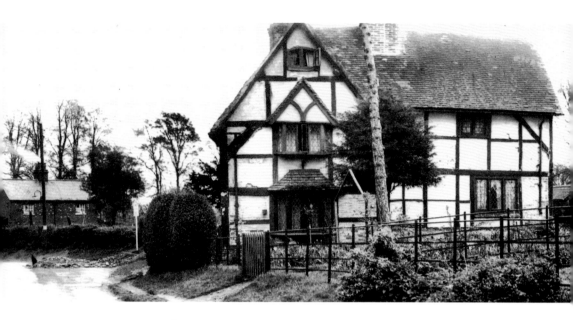

Nos 19–23 Manor Road, *c.* 1932
This house dates to the late sixteenth century, and was renovated and modernised in the following century. In the early eighteenth century, it was occupied by Samuel Wight, who was lord of the manor from 1699 to 1718. It was then acquired by Richard Blake, who succeeded Wight as lord of the manor. The house continued to be known as 'Wights'. The two brick cottages in the background were built by John Blagrave around 1862, and were demolished just after the Second World War and replaced by a modern house.

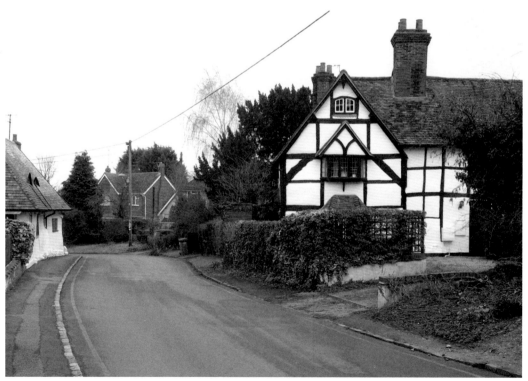

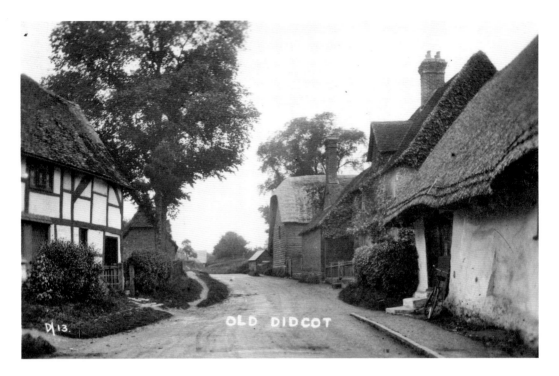

Lower Manor Road, *c.* 1925
The lower end of Manor Road around 1929, with White Cottage on the right. Opposite is the late sixteenth-century house. Before the housing development of the post-war years, it was still very rural.

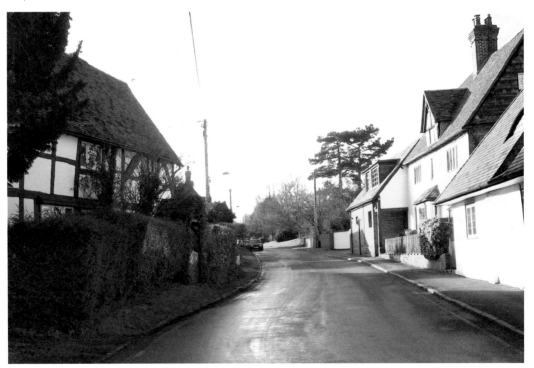

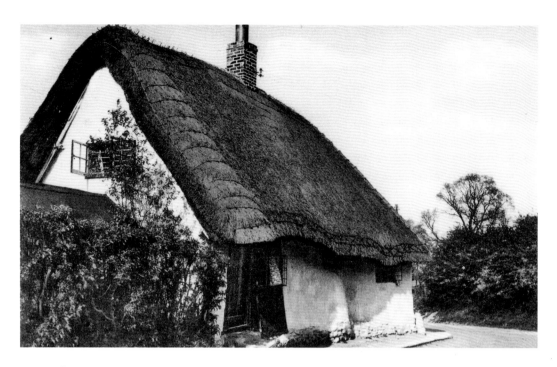

White Cottage, *c.* 1939

This is Didcot's oldest house, a timber cruck frame building, dating to the early fifteenth century. This photograph was taken when the cottage was tenanted by Reuben Hitchman, the village postman. The corner was known as 'Hitchman's corner'. The cottage has a long history of occupancy. In the mid-sixteenth century, it was the home of 'Goodwife' Dew. Today, it has been extended, and the thatch has been replaced by tiles; it was subjected to a disastrous fire in the 1960s, when the changes were made.

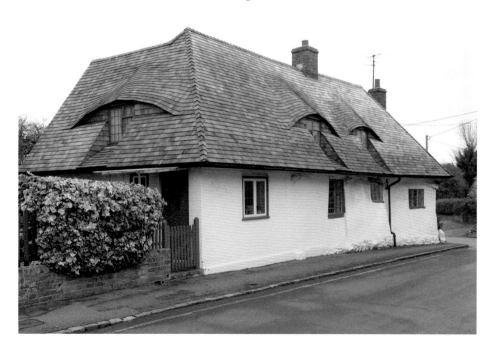

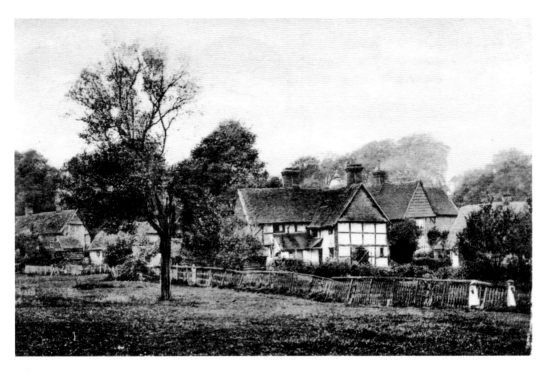

Lower End of Manor Road, *c.* 1910

To the left is the late sixteenth-century house, opposite White Cottage, and to the far right are Nos 28–30. This house was built around 1650, and possibly by John Dew, who then rented land from the Stonors, lords of the manor at that time. The villagers at that time considered this part to be the 'pretty end of the village'.

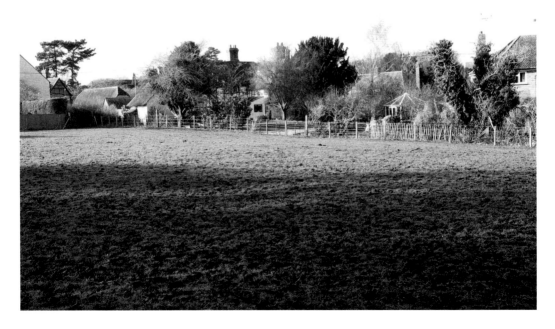

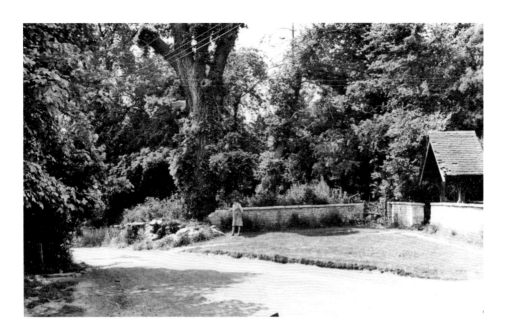

The Lychgate and Mrs Brookes, *c.* **1964**

Standing in front of the lychgate at All Saints church, in Lydalls Road, is the late Mrs Brookes. She and her husband, Claude, had purchased the bottom end of Didcot Rectory's garden from the church commissioners, complete with its enormous mature trees, which had to be felled and the land cleared before their bungalow could be built (now No. 148 Lydalls Road). When they came to create their garden, they kept turning up shards of Roman pottery. The area around the church was once a Roman settlement.

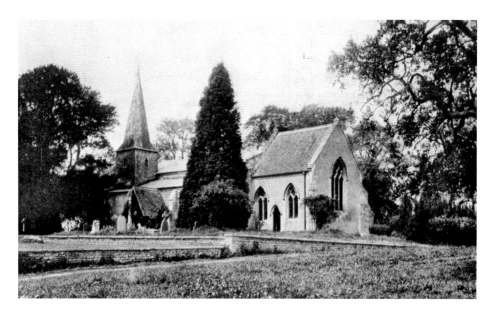

All Saints Parish Church, Lydalls Road, *c.* 1905

All Saints is early to late medieval. The nave walls probably date from the twelfth century, a column of around 1160 having been found during repair work. The chancel was rebuilt and widened around 1340 and the south aisle added at the same time. The responds of the chancel arch, the rood stairs and doorways and the west window of the nave are fifteenth century. The dedication to All Saints is also medieval. The first time it appears in the records is 1470, although it is much earlier in date.

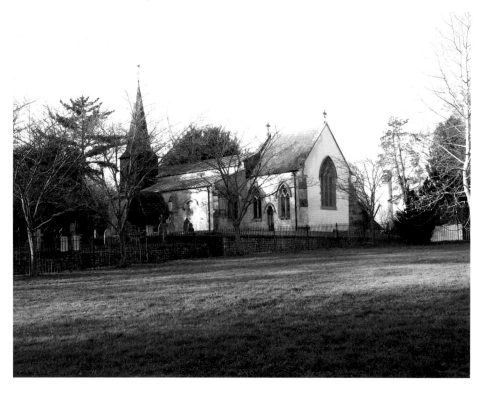

The Yew Tree,
All Saints Church, c. 1929

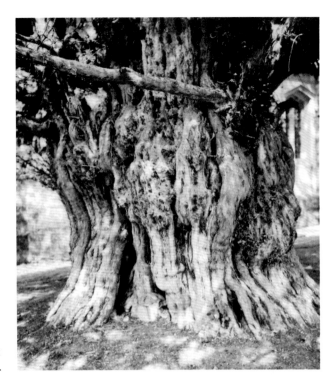

This the oldest living thing in Didcot, believed authoritatively to be over 1,200 years old; it is one of the few trees of this age to exist in England. It was certified as such by an eminent tree specialist, who examined the tree in 1970. The tree was actually planted during the Saxon era. One mystery of that time was that the name of that Saxon settlement was not Didcot but Wibaldinton or Wibaldeston. At one time, it was considered that there were two villages, Wibaldinton and Didcot, and that the former was abandoned in favour of Didcot. Further research now suggests it was far simpler than that – there was a change of name rather than an abandoned village. At that time, the manor of Didcot was part of the Honour of Cainhoe, a great barony centred on Cainhoe in Bedfordshire. The Honour had two Wibaldintons. Presumably, it was decided to rename the Berkshire Wibaldinton rather than the one in Bedfordshire (now Wyboston).

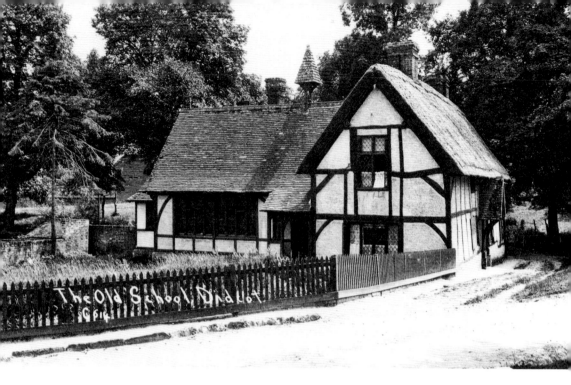

The Old School House, *c.* 1915

The Old School House was so named because the house, or rather the extension, acted as a school during the mid-nineteenth century. The house itself dates possibly to the late sixteenth century, and could be even older, but it is very difficult to date. It was the manor house before 1654, when it was rented and afterwards bought by Robert Lydall, after whom the road is named.

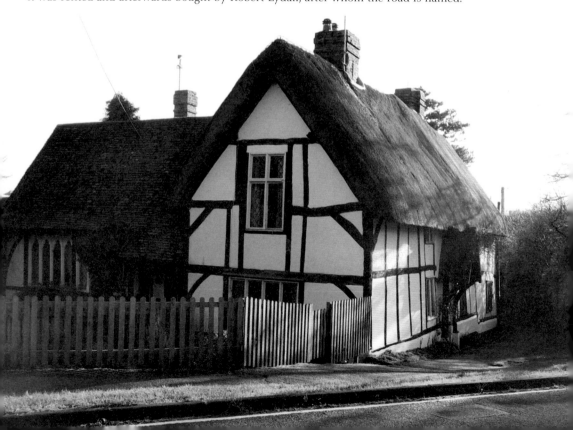

Rectory Cottages, c. 1939

Ownership of the house and farm passed to the Diocese of Salisbury in 1754. It formed part of the rector's glebe up to the late twentieth century. In the 1960s and 1970s, it used to be the home of the curate. The house was sold by the church commissioners to a private owner in the 1990s. Today it is known as 'Rectory Cottages'. Next to the cottages is Church Lane, looking down towards 'The Nook'; it connects Manor Road to Lydalls Road.

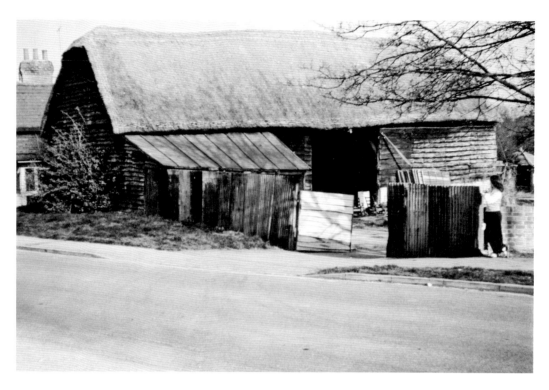

Pooles Barn, c. 1960s

This seventeenth-century barn was once part of the farm based on Rectory Cottages, and was owned by the Lydalls family. The barn was bought from the church by Mr and Mrs Poole, hence its name. It was they who demolished it and, after protracted planning problems with the local authority in the 1970s or 1980s, built these two small bungalows.

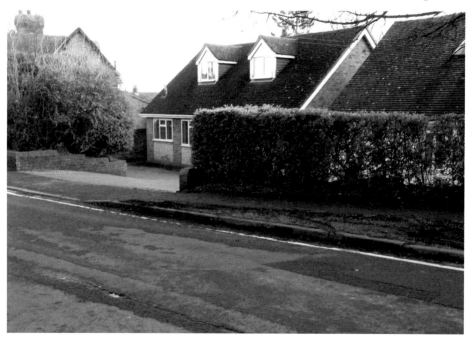

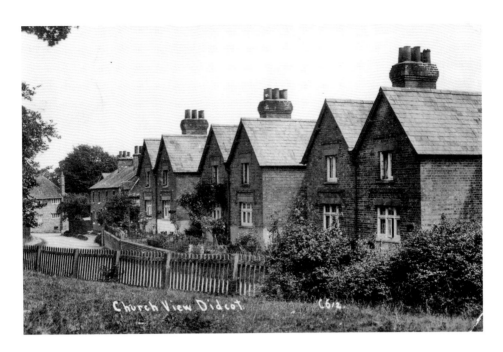

Church View, Lydalls Road, c. 1915

This terrace of six cottages was built by William Napper for farm labourers in 1893. On the front elevation of one cottage is a tablet bearing the legend 'WN 1893'. Napper was a tenant farmer, the uncle of Dennis Napper of Manor Farm. He was living at Nos 28–30 Manor Road, then known as Ladygrove Farm. This farm was then part of the larger Didcot estate, owned by Lord Wantage before his death in 1901.

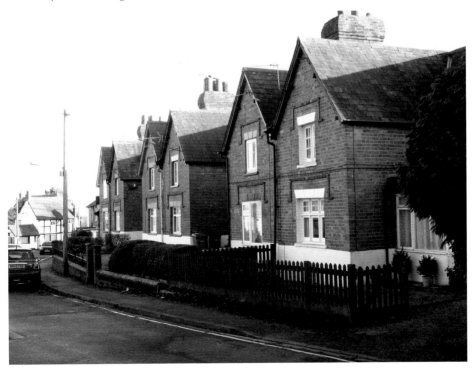

Lower Lydalls Road, *c.* **1950**

At this time, the village streets and Lydalls Road were largely undeveloped; they still had the look of village streets and the motor car was a rare visitor to this road. The cottages (Nos 117–123) to the immediate left were erected for rent in 1858 by James Banwell, a railway carriage fitter. The timber-framed house beyond is both mid-sixteenth and late seventeenth century in date.

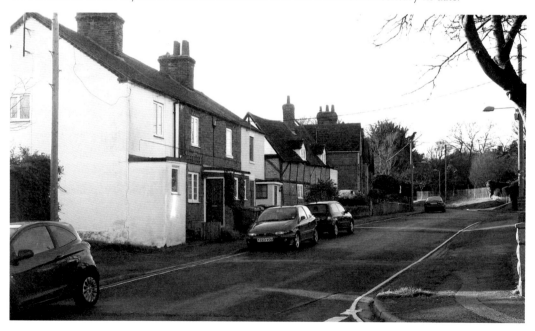

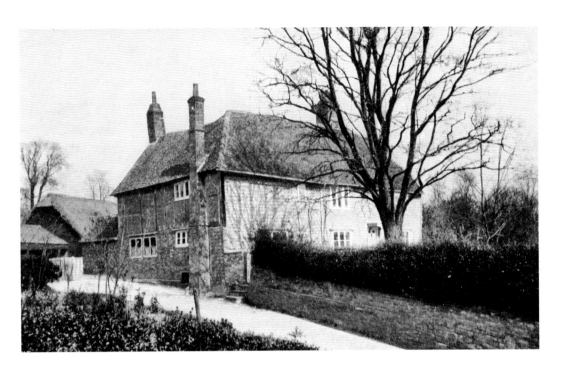

Blagrave Farm, *c.* 1905

A house of indeterminate age, possibly late sixteenth century, but it has been altered so many times over the centuries that it is difficult to date. The Blagrave association began in 1784, when John Blagrave bought the farm from the Garrard family of Lambourne. The Blagraves sold the farm to Robert Rich in 1899. As much of the farmland ran up to Broadway, it was Rich who was the prime mover in the growth of the road as Didcot's shopping centre, when he sold many frontage plots.

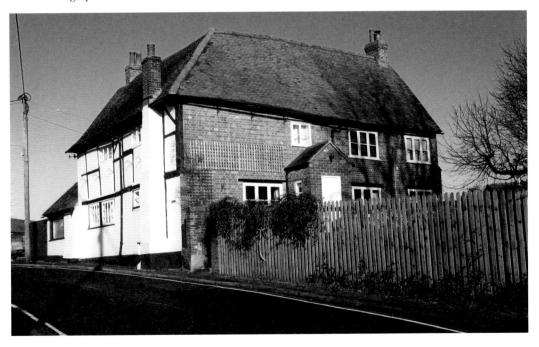

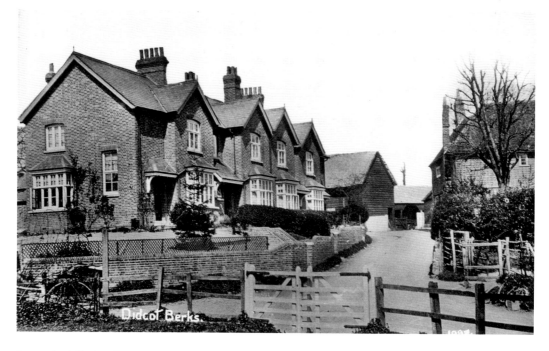

Lower Lydalls Road, 1905

Looking up lower Lydalls Road towards Blagrave Farm and its barns, which have now all gone. The row of terrace houses, or Belle View, were built around 1908 and rented by railwaymen – only they could afford the rents. Prior to the First World War, this was known as the posh end of the village by the village farm labourers.

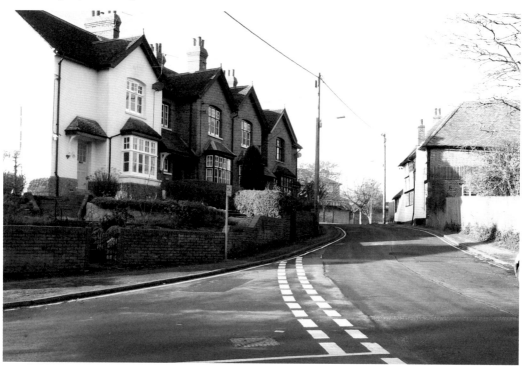

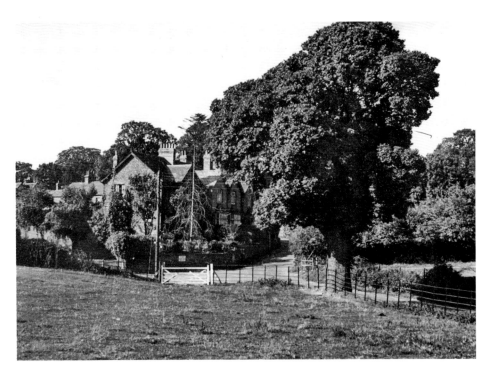

Lower Lydalls Road, c. 1955
The junction of Lydalls Road and Manor Road in the early 1950s was very picturesque and still had a village look, with narrow roads and trees. Trees are a dominant feature in many of the photographs of the early post-war years. They have slowly been cleared away since.

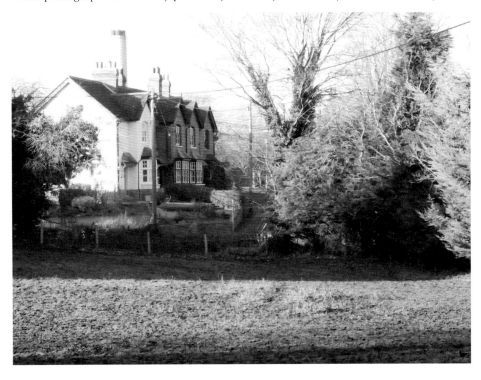

Britwell Lodge, c. 1980

This Victorian villa dates from 1852, when it was built by John Blagrave as a gentleman's residence. By the 1880s, it was occupied by Mr Arthur Stevens, who lived there with his two unmarried daughters until his death in 1914. The next year, the house was sold to Raymond Ryman, whose family continued to reside here until the 1950s. It then passed through various hands until it was sold at the end of the 1990s to McCarthy and Stone, who erected this block of retirement apartments in its place.

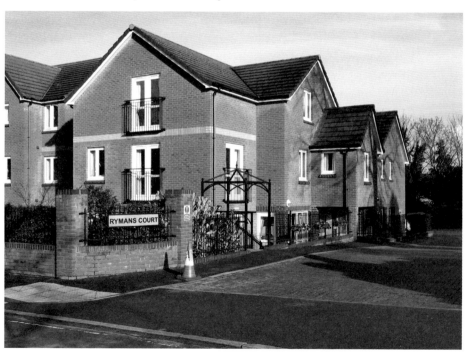

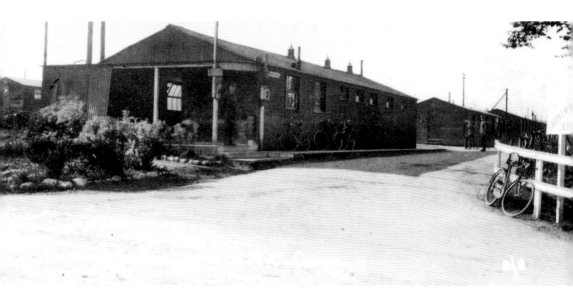

Foxhall Road, The Guardhouse, Vauxhall Barracks, *c.* 1929
The guardhouse was first erected in 1915, when work began on the Army barracks, sited at the top of Foxhall Road. This building, or its successor, was still there as late as the 1970s, when it was demolished to make way for the new link road to the A34. The new guardhouse is sited higher up the road.

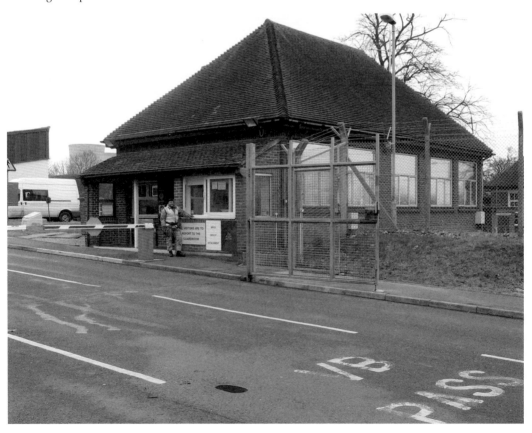

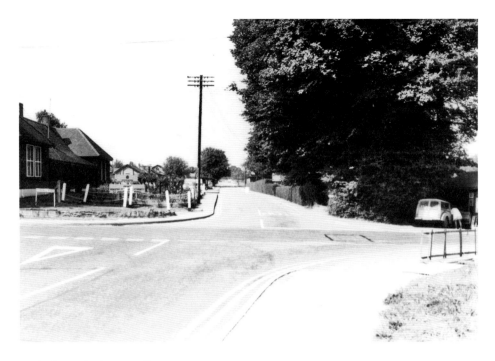

Foxhall Road, The Guardhouse, *c.* 1974

The entrance to Vauxhall Barracks around 1974 and before the new railway bridge, the link road to the A34 and the perimeter road around the top of Didcot were constructed. The road in the middle foreground gave access to the Army housing estate of The Oval. This was then a quiet road junction, but not today. The only reason to turn right in those days was to go to the caravan site or the power station. It is much busier today, especially at rush hour.

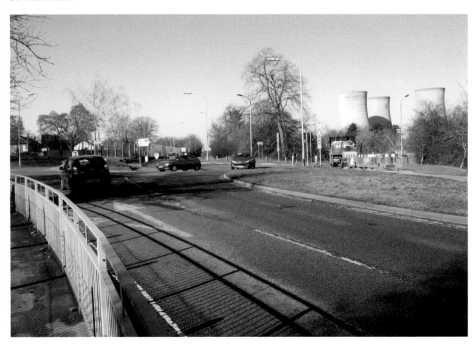

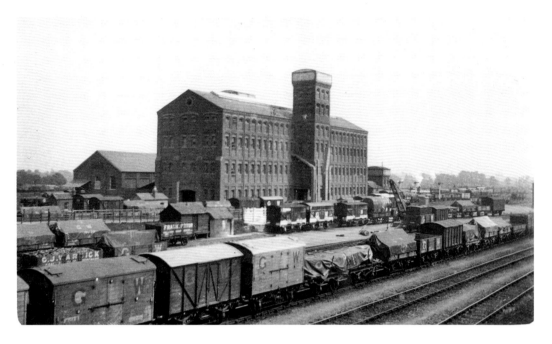

The Provender Store, c. 1929

This large building dates to 1884. It was built to supply provender for the 3,000 horses used at the many railway stations throughout the GWR's system. It was built because Didcot was central to that system, and it also stood in the middle of a large corn- and hay-growing area. As the use of horses declined in the first part of the twentieth century, it fell into disuse. The store was finally demolished in 1976. Its site and the railway sidings are now a large railway car park.

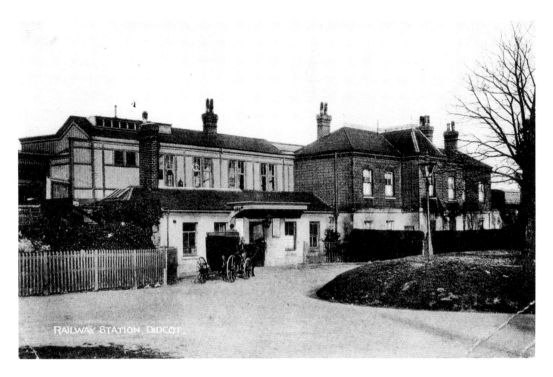

RAILWAY STATION, DIDCOT.

Didcot Railway Station, *c.* 1910 and *c.* 1929

There have been three Didcot railway stations. The first was designed by Isambard Kingdom Brunel. It was comprehensively refurbished and rebuilt in 1883 in response to increased demand, but was destroyed by fire three years later. The second continued unaltered until after the denationalisation of British Rail in the 1990s. It has now been completely redesigned and rebuilt.

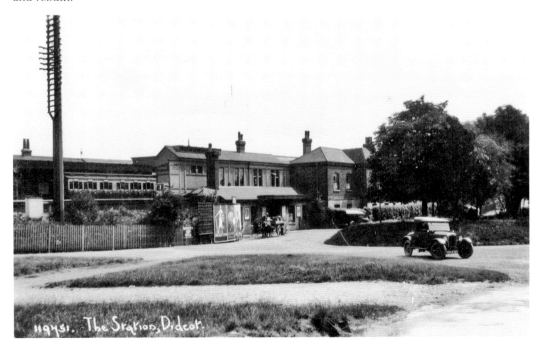

119451. The Station, Didcot.

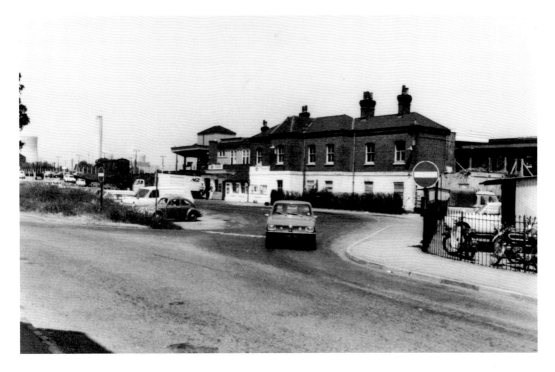

Didcot Railway Station, 1975

Since this photograph was taken, the station has been completely redesigned (as can be seen in the photograph below) and bears no comparison to what went before. British Rail did nothing to improve or update the railway station, which was essentially a Victorian building. Denationalisation brought private money into the rail system, resulting in vast improvements to Didcot railway station by First Great Western over the past decade.

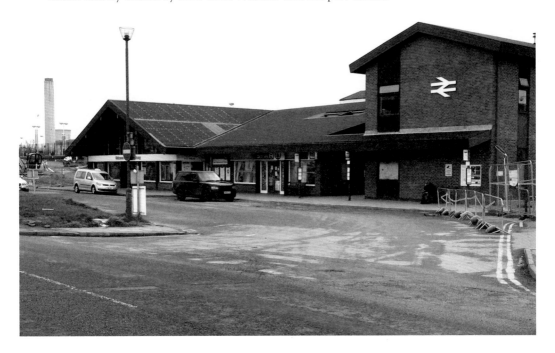

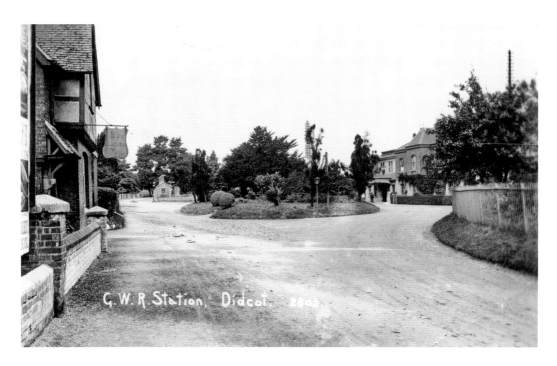

Didcot Railway Station, *c.* 1915

Before 1914, Station Road stopped at the station and ended in the form of a large roundabout. Around the roundabout was the station to the north, the Corn Exchange to the west, and the hotels, an inn and a shop, on the south side. In 1915, with the arrival of the Army and establishment of the Barracks and the Ordnance Depot, came the need for a link to the railway station, and Station Road was extended to provide this connection. The railway station area today is shown below.

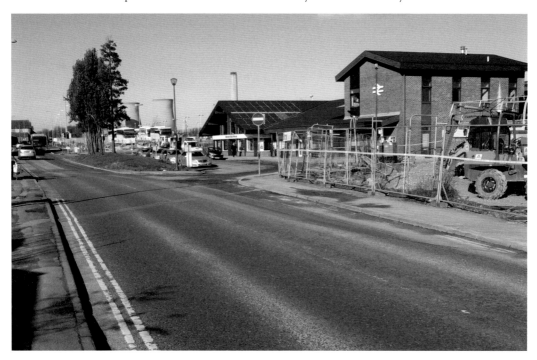

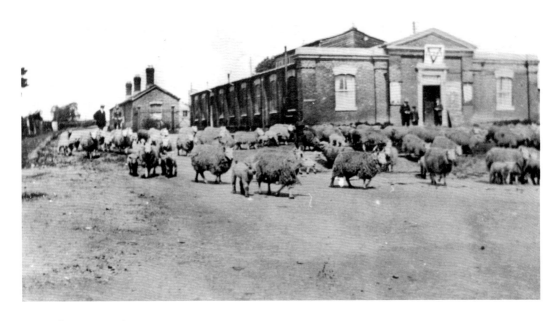

The Corn Exchange, c. 1920s

The railway had many uses; not only did it transport people, but it also conveyed animals to market, as in the case of these sheep. When the railway was first laid down in the 1839, its primary aim was commerce, rather than transporting people. Such was its success that in 1857, Didcot Corn Exchange was opened (the building in the middle foreground). Its aim was to bring together farmers and dealers to buy and sell agricultural products and animals; people came from all over the country, even as far as Yorkshire.

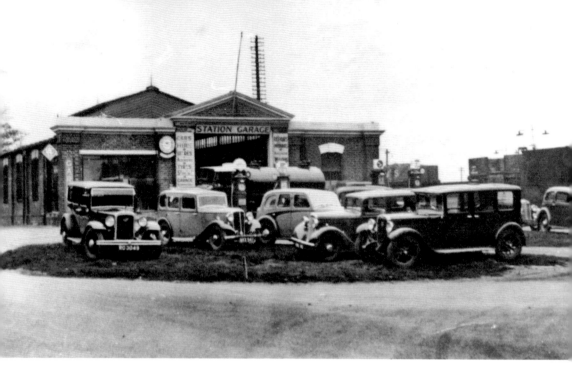

Station Garage, *c.* 1945

The Corn Exchange closed for business sometime before 1900, after which it passed through many hands. It was a YMCA during the First World War, then in the 1930s usage changed to that of a garage (Station Garage). This usage continued until the owners, Monty Dipper, built a new garage (now Julians) on the other side of the road.

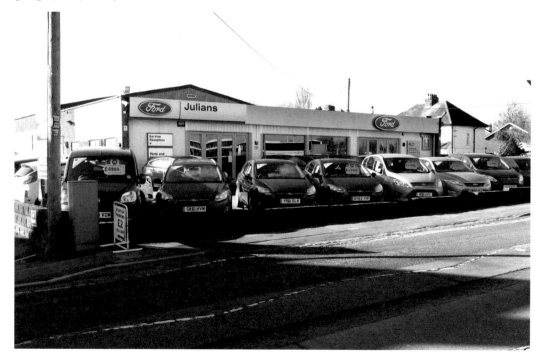

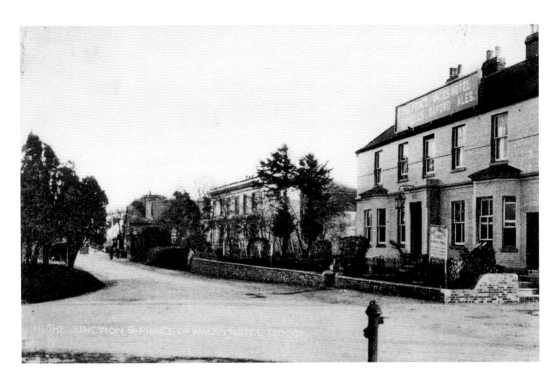

The Station Hotels, *c.* 1915

The opening of the Corn Exchange led to the building of the Prince of Wales, the Great Western Hotel, the Royal Oak Inn, a shop and a baker, all before 1862. The Corn Exchange attracted so many dealers to Didcot that there was always demand for accommodation in the two hotels. At times, demand was so great that rooms in Blagrave Farm in the village were made available. Though the Prince of Wales still exists, all the other buildings have been demolished. The station area is in the process of major development.

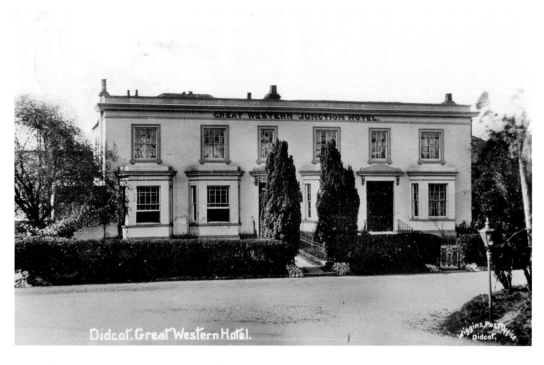

Didcot. Great Western Hotel.

The Great Western Junction Hotel, c. 1905

This hotel was built in 1846 to cater for early travellers on the Great Western Railway. Travel arrangements in those days were quite primitive. Today, if we want to travel and have to make changes, one ticket would cover our whole journey, irrespective of any detours, but this was not so in the early years of the railway. You had to buy a ticket for each leg of your journey, which could cause long delays, hence the need for this hotel. Unfortunately, the hotel has now been demolished, and a car park has taken its place, but a large new hotel is soon to be built on the former site.

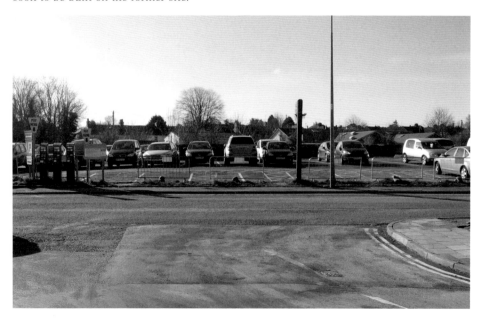

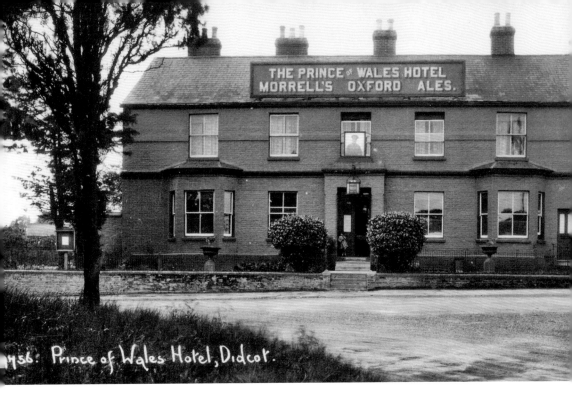

1956: Prince of Wales Hotel, Didcot.

The Prince of Wales, *c.* 1929

This hotel was built in 1860/61, in response to the opening of the Corn Exchange, which proved to be so popular that accommodation was urgently needed by the many dealers visiting Didcot to trade. There have been two noteworthy landlords: Peter Playfair, who was the first, described in 1861 as 'a penurious scotchman who was never known to give anything away but a pinch of snuff'; and William Walters, of the 1920s and '30s.

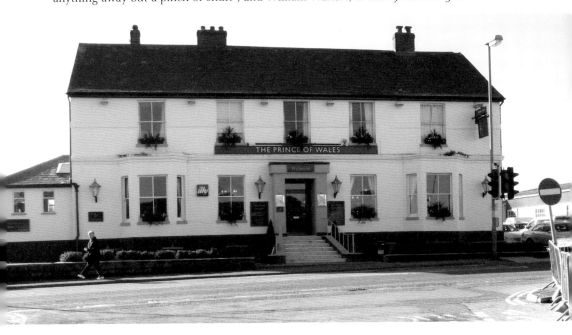

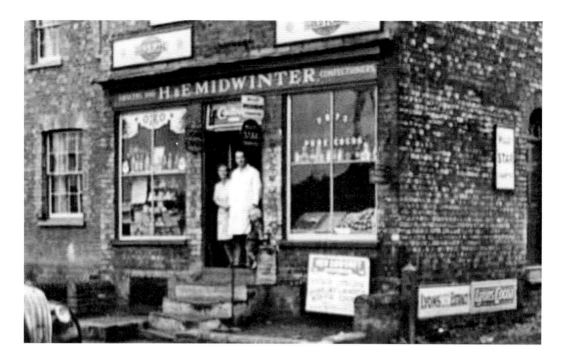

Midwinter's Grocery Shop, 1963

This shop formerly stood opposite the railway station. At that time, there were many more railwaymen than there are today, making the shop a profitable concern, although the Midwinters began to lose out to the supermarkets opening in Broadway during the early 1960s. The family left the shop after the death of Mr Midwinter in May 1963. Standing in the doorway is Henry Midwinter, his wife, Esther, and daughter, Josie. It was built by John Thomas Pryor in 1860 in response to the trade generated after the opening of the Corn Exchange. The shop was demolished at the end of the last century as part of the renewal of the station area. This site will be part of the new hotel complex.

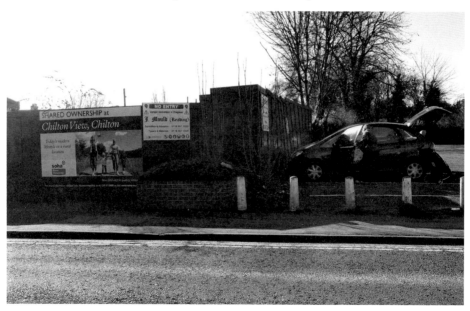

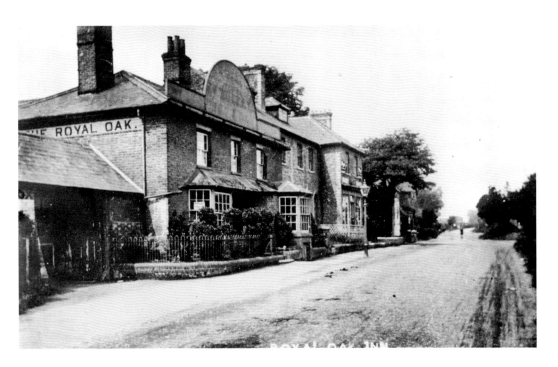

Royal Oak, c. 1920

The public house at the station was the Royal Oak, built in the same decade as the Prince of Wales. It was never successful, being too small and in competition with the Junction Tap, which was part of the Great Western Hotel. It closed down in the late 1920s and a new, larger pub was opened in Park Road to serve the new housing estates of Norreys Road and the Vestas, Fairacres Road, etc.

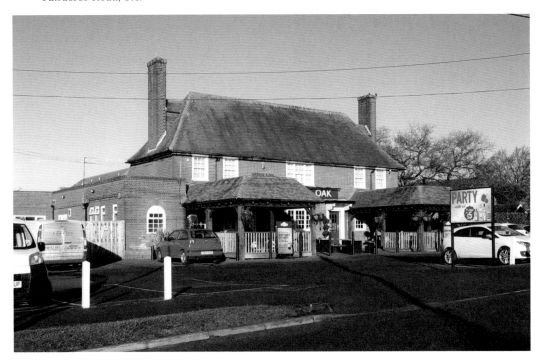

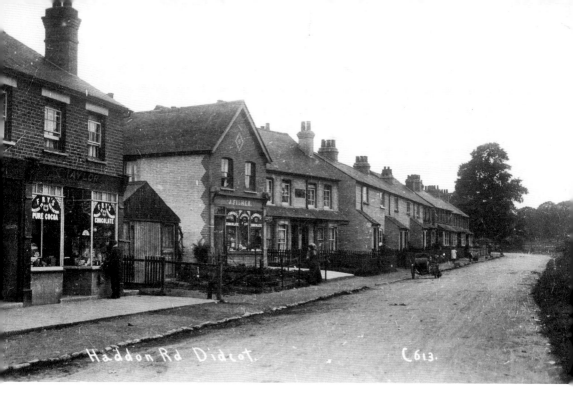

Lower Lydalls Road, c. 1915

It's very hard now to believe that these two shops survived profitably on the trade from houses in Station Road and lower Lydalls Road, some fifty-plus in all, but they did. The first shop above was that of David Monger, a confectioner; the further shop was that of a grocer. To the left of Monger's was Lloyd's Bank. It was the opening of the shops in Broadway during the 1930s that brought about their inevitable closure.

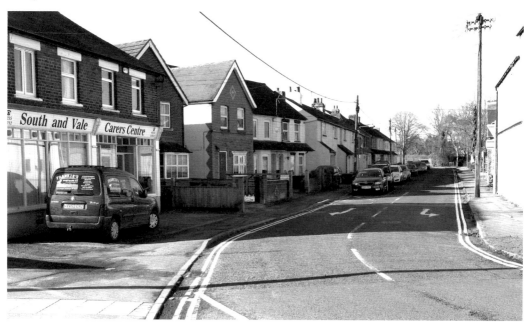

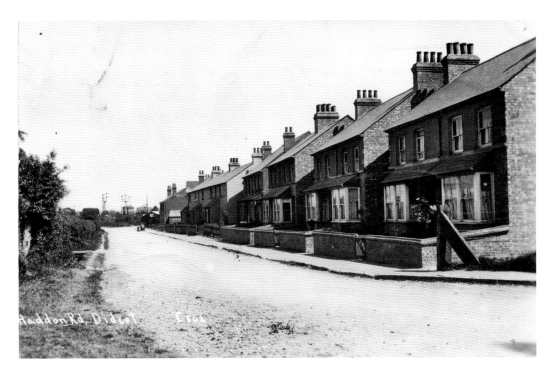

Haddon Rd. Didcot C502

Lower Lydalls Road, *c.* 1915

At this time, the road was known as Hadden Lane. Before the advent of the railway, it was the link to The Hadden, a wooded area that, before 1841, had been the village's common, hence its earlier name. The houses pictured were built in 1901 by Robert Rich on land belonging to Blagrave Farm, which he had bought two years earlier. In the far distance can be seen a large shed, which then housed the first WHSmith's shop.

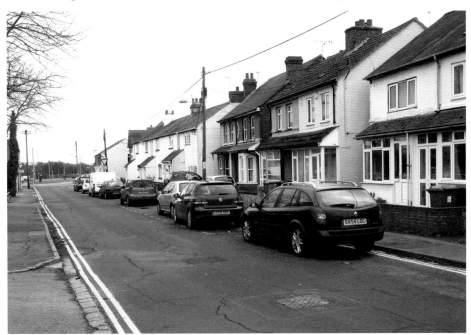

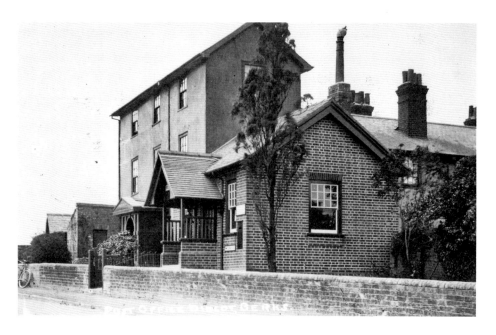

Station Road, *c.* 1920

The large building then sited at the top of Station Road was the stationmaster's house, which was replaced when the new station, incorporating his new quarters, was built in 1886. It then became Didcot's postal sorting office, with the smaller building in the foreground serving as the post office. By the late 1960s it was derelict, and the sorting office and the old post office were demolished and replaced by the new Keymarket's supermarket. As part of the development of the Orchard Centre, the supermarket was in turn demolished and replaced by the SODC's Cornerstone Arts Centre in 2009.

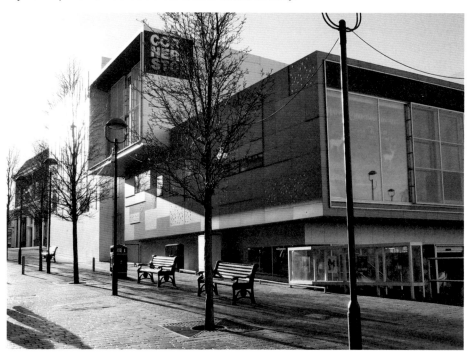

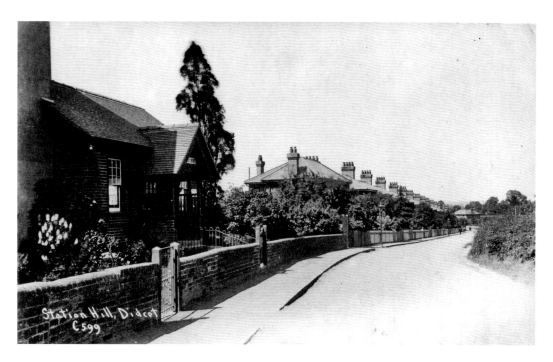

Station Road, c. 1915
Didcot's second post office was built around 1912 and arrived just in time for the increase in postal traffic during the First World War. Standing on the site of Wallingford Rural District Council's former car park is the modern Cineworld cinema. In earlier days, especially before 1939, Station Road was known colloquially as Station Hill.

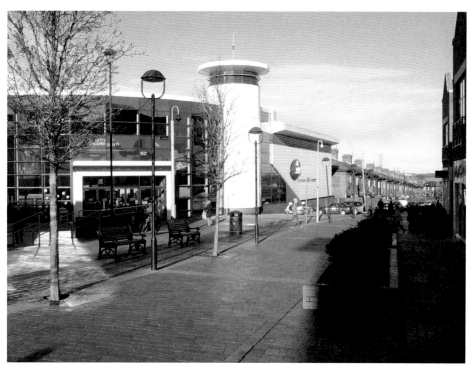

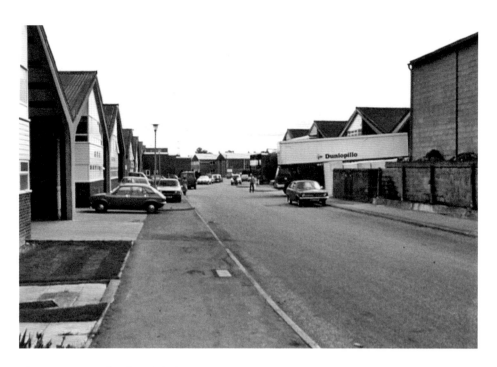

The Station Road Industrial Site, 1975

These factories, all established in the 1960s, were swept away to make room for Didcot's Orchard Centre and its modern shops. The industrial site was established by Wallingford Rural District Council in 1964 to provide extra jobs for the townspeople, though there was full employment in those years. Below is the main street of the new shopping centre.

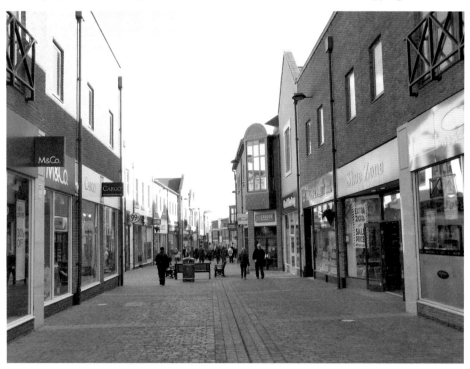

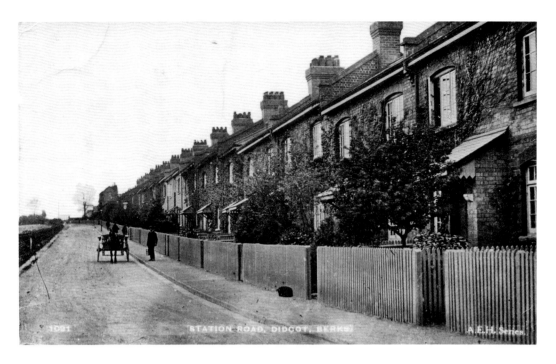

Station Road, *c.* 1915

These houses were built in 1903, exclusively for the use of railwaymen and their families. They were owned by both the GWR and British Rail in turn, until the latter sold the houses to Wallingford Rural District Council in 1967. At the time the postcard was issued, Station Road was still a tranquil country road, which cannot be said of it now.

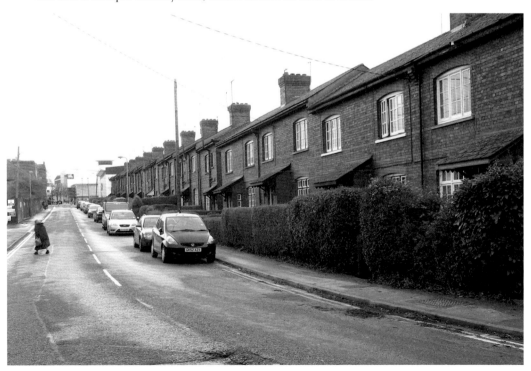

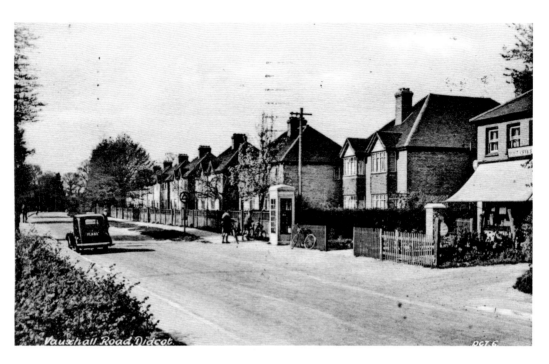

Foxhall Road, c. 1939

The houses shown were built by the Didcot building firm, Blakes Bros, in 1933. They are largely unchanged today, the only difference being that the road was quieter then.

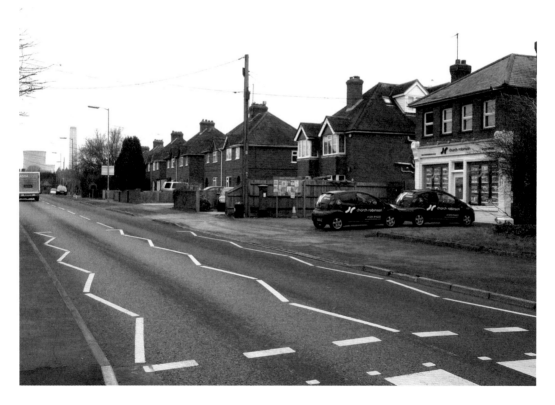

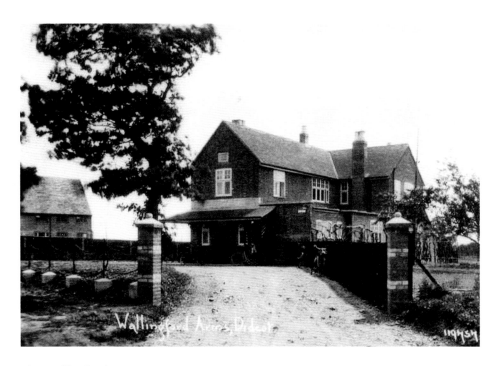

The Wallingford Arms, c. 1929

The Wallingford Arms is contemporary with the Marlborough Club, which can be seen in the background, and is sited further along Broadway; both date to 1927. The reason for its construction, as given by the Wallingford Brewery Ltd, was that the population of Didcot had increased enormously and there had been a large number of houses erected in the vicinity of the public house; as such, there was extra demand for licensed houses.

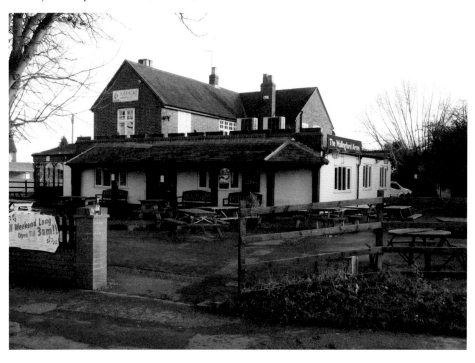

Britwell Road, c. 1939

Britwell Road as seen from the roof of the New Coronet, which was then a quiet country lane. The war brought an end to this rural peace when in 1940 the Canadians built an Army camp, which was turned into a camp for both Italian and German POWs at the end of the war. The camp was then converted into council accommodation and later, Blakes, the building firm, having bought the site from Geoffrey Ryman, built the housing estate of Blenheim Close and Blagrave Close. The frontage of the site now holds the Didcot Health Centre and the ambulance station.

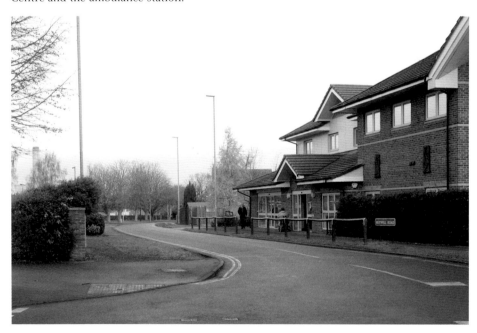

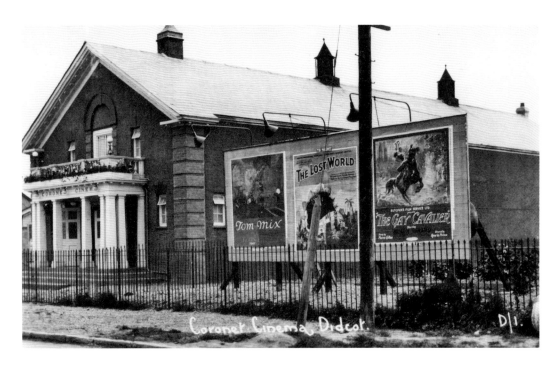

Didcot's First Cinema, 1929

The Coronet cinema was built by W. E. Cullen and his two sons, William and Hector. The family had noticed how popular cinemas were becoming, and erected the cinema entirely by themselves, on land purchased from Dennis Napper of Manor Farm. It opened in 1926 and proved to be a great success, so much so that it was replaced by another cinema, The New Coronet, in 1933. The library now stands on the cinema's former site.

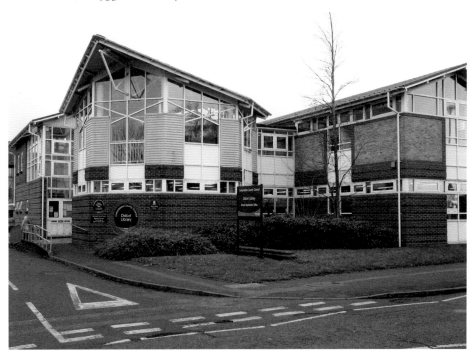

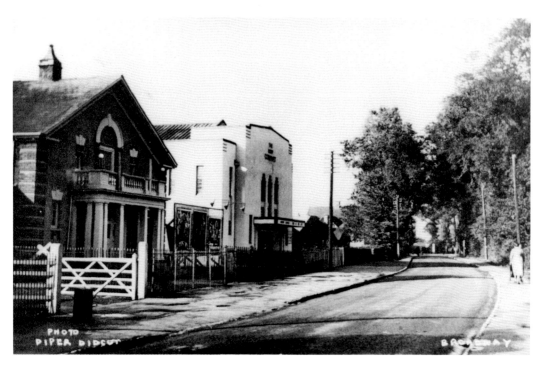

The Two Cinemas, *c.* 1939

The earlier cinema was converted into a ballroom, which proved as popular as its predecessor. It was bought by the Co-op just after the war and, despite strong disapproval at the loss to the community, was turned into a large department store. This, in turn, was acquired by the county council at the end of the 1980s and, the earlier shop being empty, was replaced by a new library (opened in April 1992). By the early 1970s, the New Coronet had ended its day as a cinema and was converted into a bingo hall, which today is just as popular.

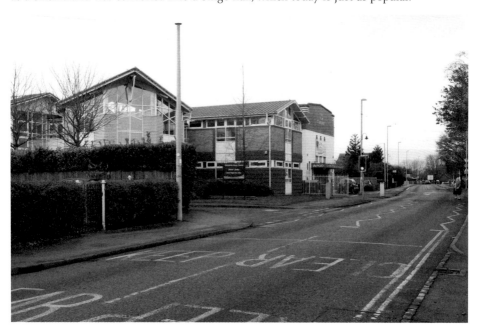

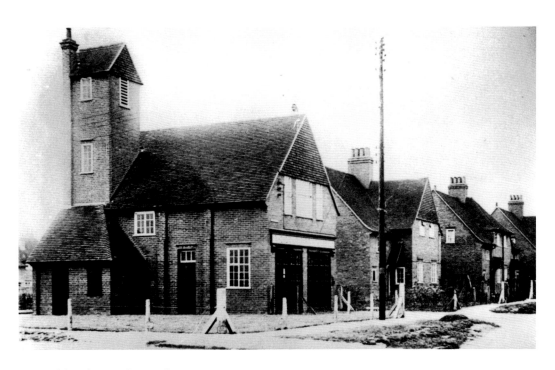

Old and New Fire Stations

The earlier fire station stood formerly in Wessex Road and dates to 1929. A grand opening ceremony was held in July 1929 by John Kynaston Cross, then chairman of Wallingford Rural District Council, attended by the good and great. It was eventually replaced by the modern station in Broadway in December 1952. The opening ceremony was much quieter.

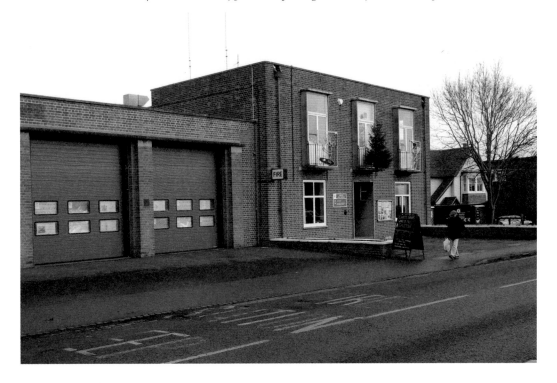

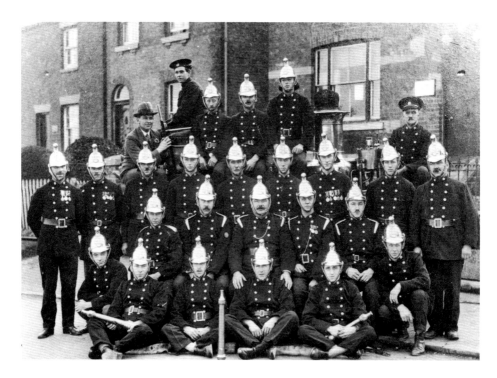

Firefighters of Yesterday and Today

Above, the firefighters of the 1930s with ex-police sergeant C. A. Perry (second row, centre) as chief of the Didcot Fire Brigade, and, below, today's Red Watch (left to right): AWM Andy Halstead, FF Gordon Daly, FF Richard Knight, and CM Rick Hartley.

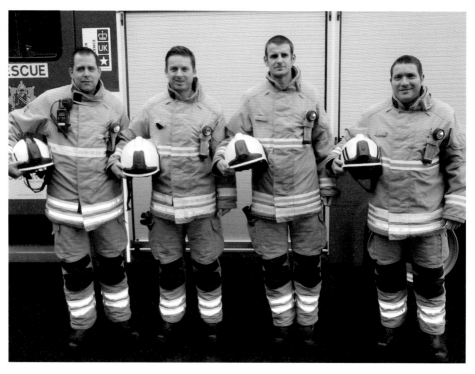

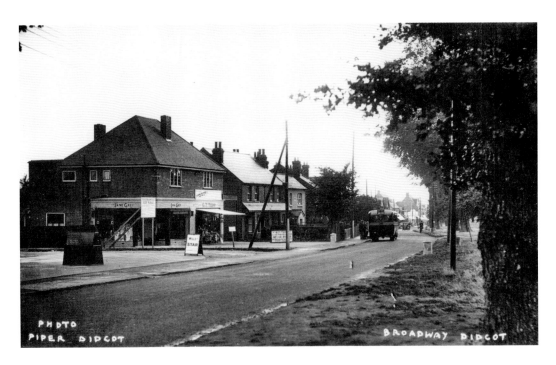

Broadway, c. 1939

The shop above, which is now occupied by an estate agent, sold men's and women's clothing for much of its history. At the time the photograph was taken, Jane Grey was trading here, selling women's clothing before and for long after the war. She was followed by other shopkeepers, such as Sneezby, who also sold clothing. Many of Broadway's shops are now occupied by estate agents, such as Chancellors, sited on the opposite side of Haydon Road, a shop that was a tobacconist's for most of its history.

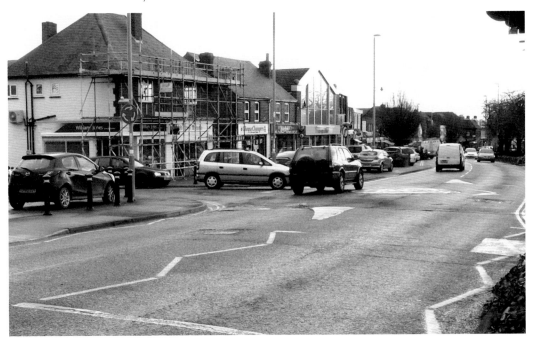

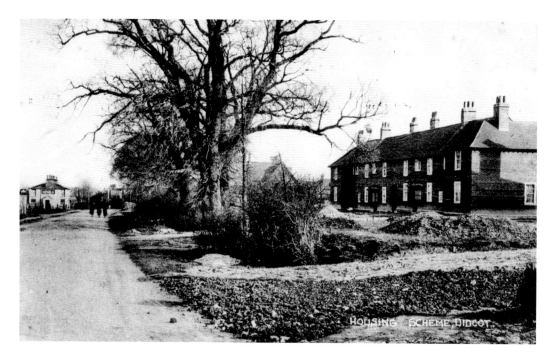

Broadway, c. 1925

Two views of Broadway around 1925. At that time it was known as the Wantage Road or the Harwell Road. In 1929, the road was renamed Broadway to end this confusion. It was named after the New York Broadway. The two postcards show council houses on the right, built in the early 1920s. The residential houses on the left are earlier, dating to the 1900s, built on land sold by Robert Rich after he had acquired Blagrave Farm. In the upper picture, the old White Hart is just in view.

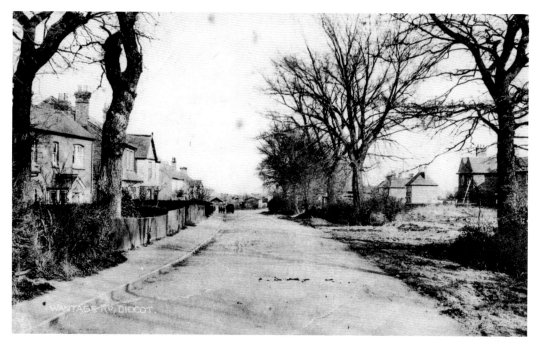

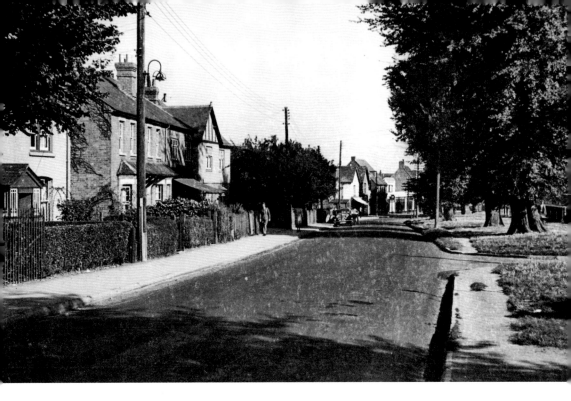

Broadway, c. 1951

Virtually the same scene, but twenty-five years later. The residential houses on the left in the above photograph have yet to be torn down to make way for the modern shops. The main villa (third from the left) was known as Sunnysides and was built by Dennis Napper for his son, Fred, around the turn of the twentieth century. In his time, Napper was a very prosperous farmer, living at Manor Farm in Foxhall Road, and virtually ran old Didcot. In later years, the house served as the surgery for Trent's, the dentist's. The house was demolished around 1960, and its site is now occupied by WHSmith.

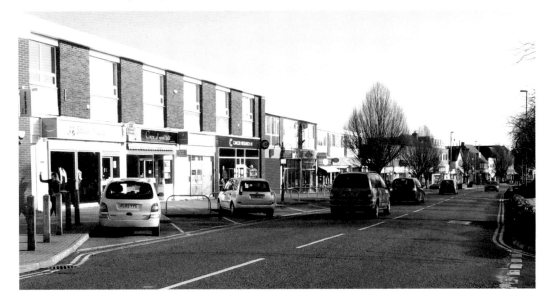

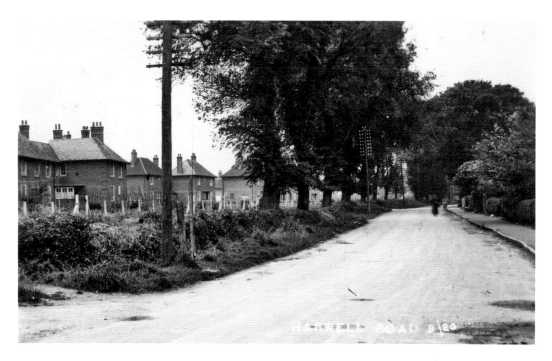

Broadway, *c.* 1925

Harwell Road (now upper Broadway), sometime in the early twenties. The road was called Harwell Road when looking up, and Wantage Road looking down. It was also known, from below Mereland Road, as Wallingford Road. The postcard shows a tranquil scene, yet to be sullied by the motor car. The council houses were built by Wallingford Rural District Council from 1919 to 1925. To give some sense of location in relation to today, the shop on the left (below) is now part of Peacocks clothing store.

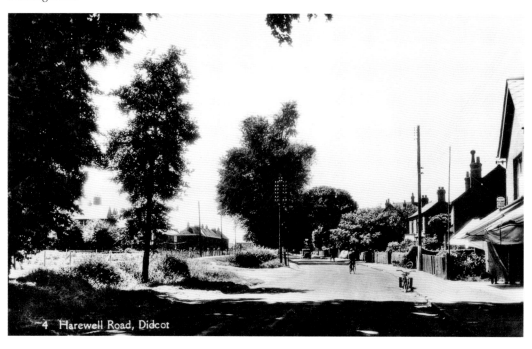

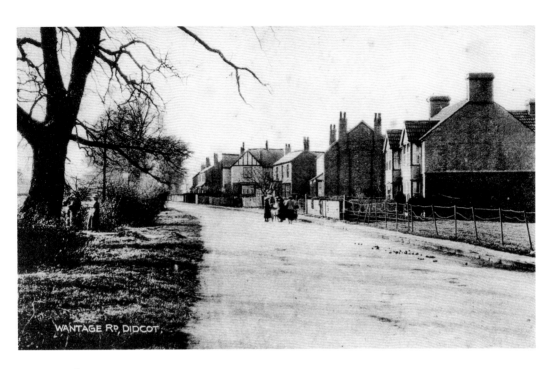

Broadway, c. 1925

Looking up Wantage Road, the road was still very residential at this time. The photograph was taken at a time when people could stand in the road gossiping without being mown down by cars, as would happen today. The shops below belonged to a future time and would not be built for another thirty years. Most of the houses were demolished in the 1950s, starting with the first semi-detached house in 1955, which was replaced by Woolworths, now Scrivens, the opticians.

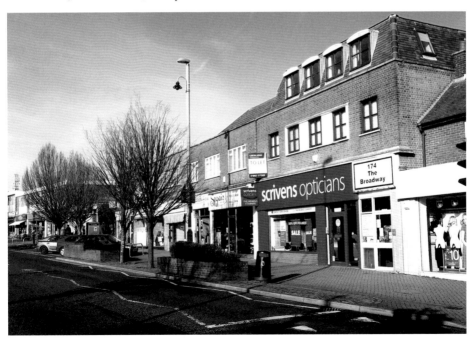

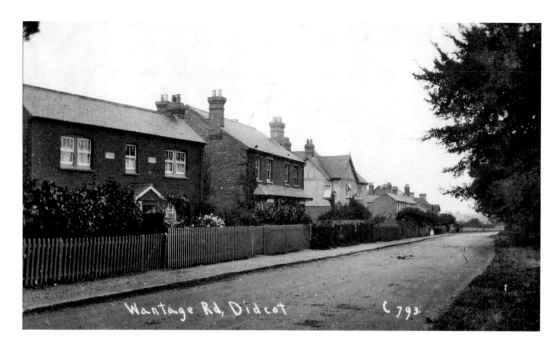

Broadway, c. 1915 and 1929

The top photograph shows that no commercial activity had taken place by the time of the First World War. It was still a country road and the housing sequence ended with the semi-detached house, shown below. The lower illustration, from 1929, shows that shops had been opened by then. Note the tin shack, which housed the shop of Annie Barber, a grocer, which is sited next to the semi-detached property. Built afterwards was the pair of houses sited to its right. These still exist and have been turned into one large shop, which now houses Peacocks. The Cullens had one of these shops in the early 1920s, trading as men's outfitters. Below can be seen the new public house, then the White Hart, now Broadways.

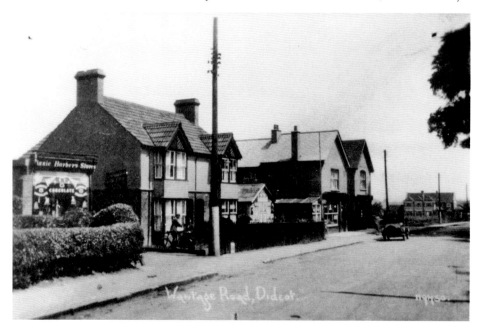

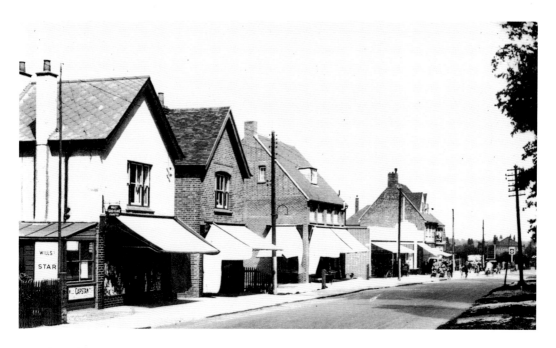

Broadway, *c.* 1935

Broadway, which had by now become Didcot's shopping centre, as can be seen by comparison with previous illustrations, developed rapidly during the early 1930s. Not only is there another tin shack, like that of Annie Barber's, but there are new shops such as Champion's, the ironmonger's (third shop along); the Co-op, (the long one-storey shop); and WHSmith, the fifth shop in the sequence.

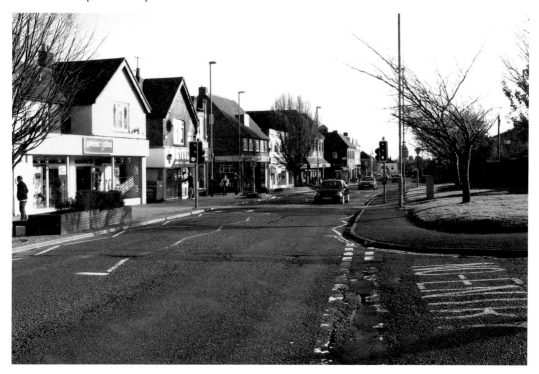

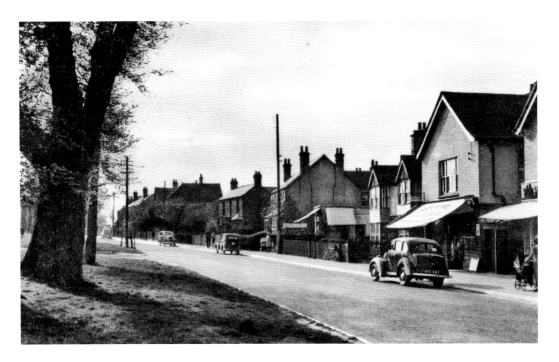

Broadway, c. 1939

Not much change occurred during the 1930s. There are very few cars or pedestrians. There was no reason for shoppers to go beyond this point, past the shops on the right. There were other shops, but these were sited much further up, next to Haydon Road and way beyond the residential houses. In the immediate post-war years, those shopkeepers, feeling that they were being ignored by shoppers because of their isolation, had placed a large advert in the *Didcot Advertiser*, pointing out where they were located. The houses have now long gone, demolished to make way for the shops now sited there, as shown below.

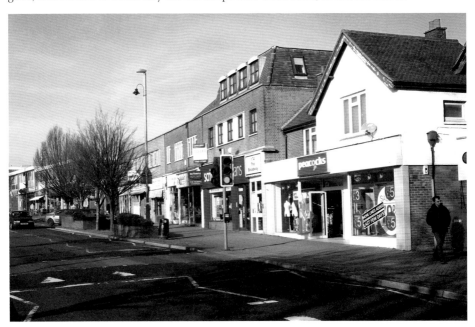

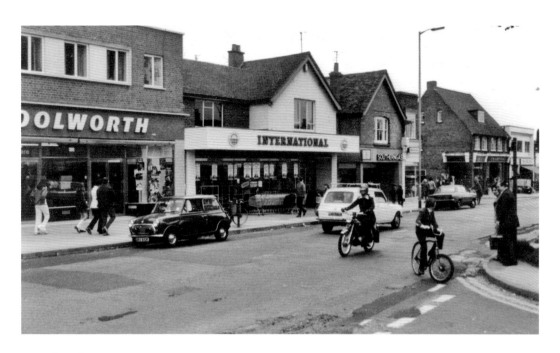

Broadway, 1974

Woolworths, the International (a supermarket), the Gas Showrooms and, on the corner (but unseen), Currys. Opposite Currys is Champion's, the ironmongers, and next door, is Milwards, the shoe shop. All are now gone, having been destroyed by economic forces, either beyond their control, or dictated by change. Currys shut in the early 1980s, when the chain began opening larger stores, as at Oxford, for instance. International went when two new large supermarkets were opened in the former market area. Of these, one still remains, now Wilkinsons, the other demolished to be replaced by Cornerstone. Champion's, a branch of the main shop at Wallingford, was gutted by fire and did not reopen.

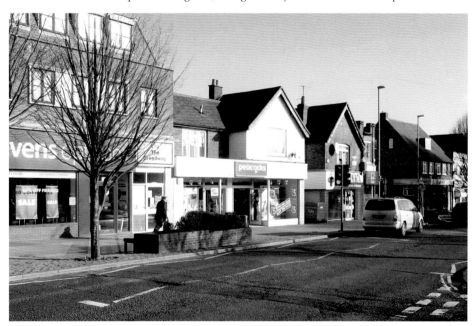

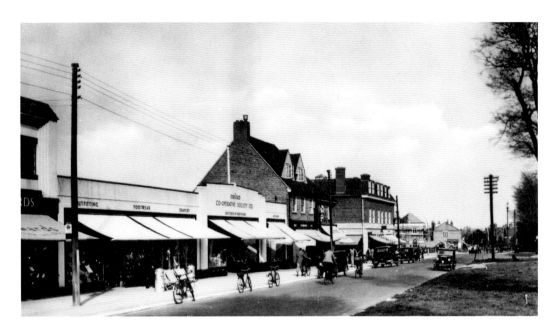

Broadway, *c.* 1939

All the shops shown above were opened in the 1930s: the large Co-op store, the original WHSmith's was next door to the right, and, to the left, Milwards, the shoe shop. Beyond, unseen, is another shop, at this time occupied by Paine's, the ironmonger. The Co-operative owned the freehold to the site of all these shops (except Milwards) and of much of the land at the rear. Then, in the mid-seventies, the Co-op cleared the site and built a new complex of two large supermarkets, other shops, offices and a new bank. Some of these new shops front Broadway, as can be seen below.

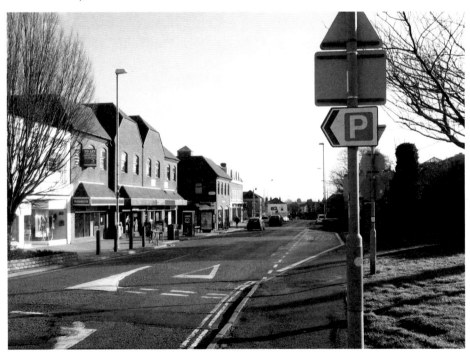

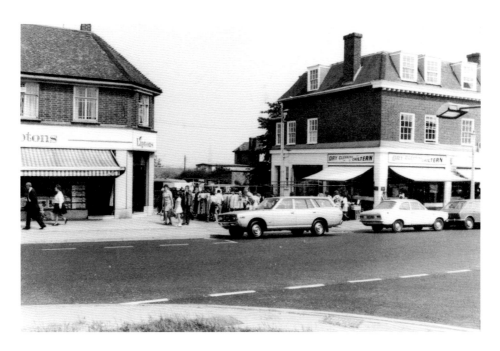

Broadway, c. 1974

The market place before the Co-operative cleared the area, including the shop building then occupied by Liptons, a food shop (formerly Home and Colonial). However, there is still a market. The two large supermarkets built by the Co-operative were sited to the rear of the market place. Liptons was replaced by a new building, now Santander. Keymarkets, whose former shop (now occupied by WHSmith) lay higher up Broadway, moved into one of the new supermarkets. The Co-op occupied the other.

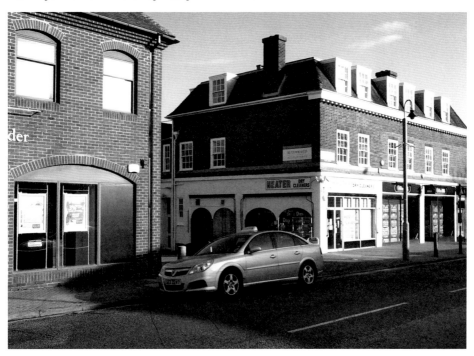

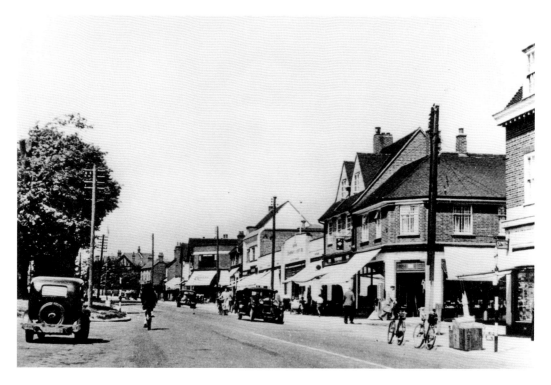

Broadway, c. 1950

Looking up Broadway in the early 1950s. The shops demolished in the late 1970s are those on the right: the large Co-op, WHSmith, and Home & Colonial (later Liptons). Higher up and hidden behind its sun blind is Currys, which opened here around 1935. The houses further up Broadway have yet to be cleared away to be replaced by the modern shops of today. This process started in 1955.

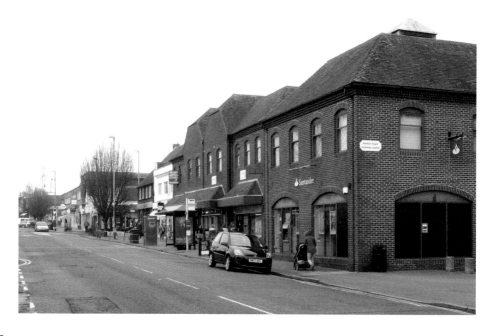

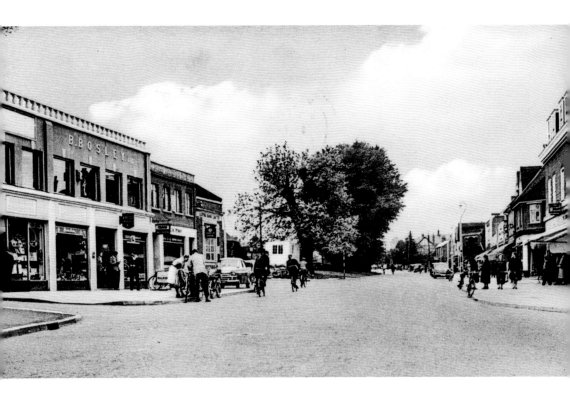

Broadway, c. 1955

Looking up Broadway in the mid-1950s. It was then a peaceful car-free road, the bicycle being the main means of transport. The shop on the left was owned by Ben Bosley, an important member of the community prior to and during this period. He had been instrumental as chairman of the fundraising committee in the siting and building of Didcot Hospital. Ben and his brother, William, came to Didcot in 1904 and set up shop in lower Broadway. The family left Didcot in the late 1970s.

Broadway Council Offices, *c.* 1975
After the creation of the new South Oxfordshire District Council in 1974, the headquarters of the previous council (Wallingford Rural District Council) on Broadway became redundant. The new authority opened its offices in Crowmarsh and the old building was demolished. On its former site, the Baptist church built its headquarters, the Baptist House, in the 1980s.

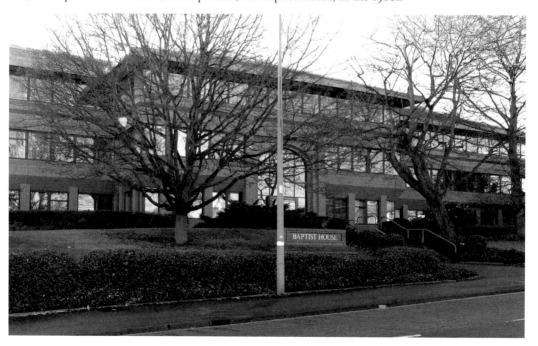

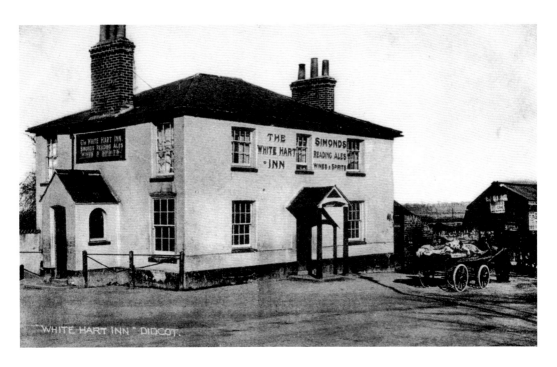

Broadway, The White Hart Inn, *c.* 1915

This old inn of 1846 was built by Simonds Brewery some two years after the opening of Didcot railway station. Here it remained until 1927, when it was demolished to be replaced by a larger and more comfortable public house. The reason given was that it was now too small and the then licensee said that she could not serve food, as was frequently requested. It was demolished in 1927, to be replaced by the modern public house, which, originally, was also named The White Hart, though the name was changed to Broadways in the 1970s.

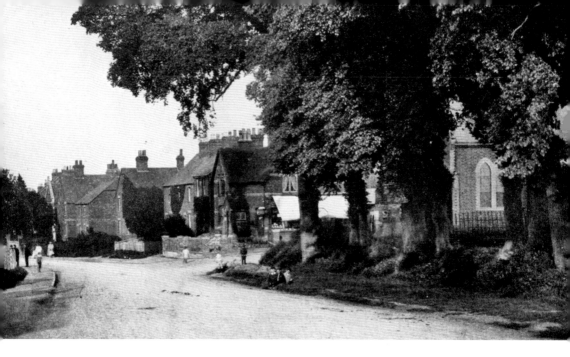

Broadway, c. 1905

Broadway at a different time in its history, then known as Wallingford Road. There was farmland all around, and behind the trees lay the Methodist church, built in 1903. The Methodist church is still there, but its setting today is very different and very modern. The trees went a long time ago and the road now has kerbs and pavements.

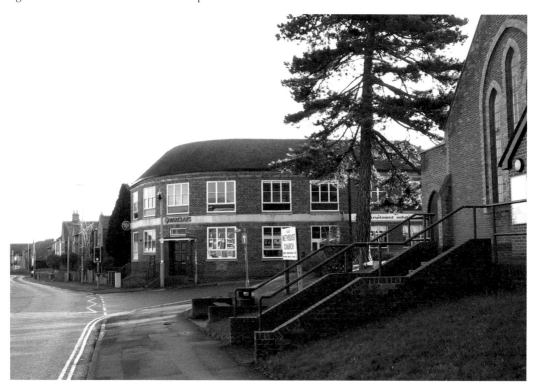

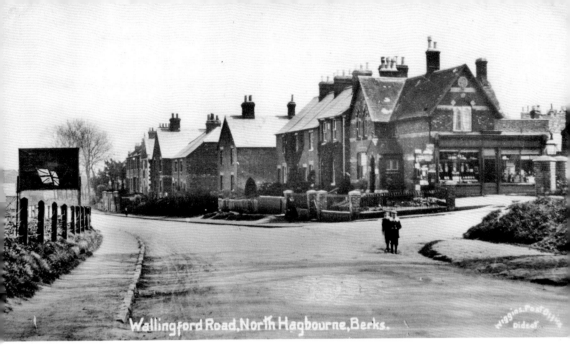

Wallingford Road, North Hagbourne, Berks.

Broadway, c. 1915

Virtually the same scene, but a few yards further down. The large house on the right was Highfield House of 1870. It was converted into a chemist's shop by a Mr Cowling. He caused quite a scandal at the time when he committed suicide in 1908. The shop was acquired by Barclays Bank in 1922. The bank first came to Didcot in 1915, in response to the establishment of the Army Ordnance Depot. The house was demolished and the modern bank building, after many alterations, has slowly taken its place.

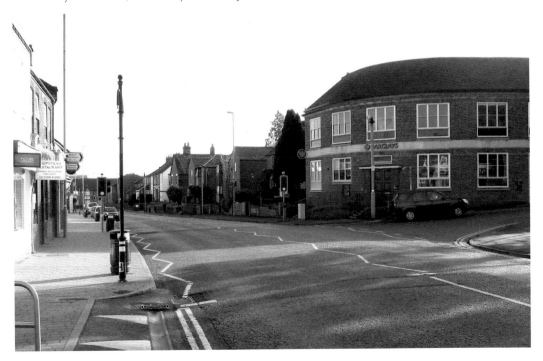

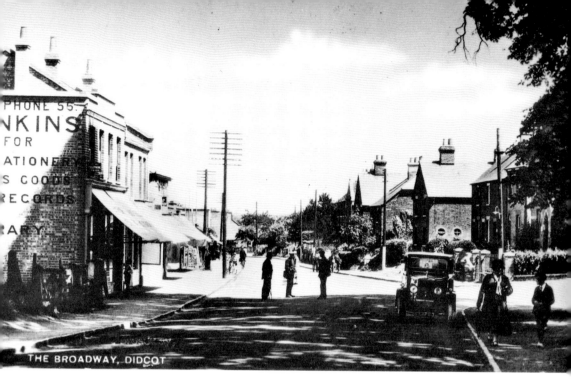

THE BROADWAY, DIDCOT

Broadway, c. 1929

Wallingford Road during the late 1920s. Jenkins (on the left) has just been built, as has the shop next door, Hedges the baker's. Arthur Jenkins was a well-respected tobacconist and newsagent. Lower down, Pengilley's Parade is just being built and scaffolding can be seen. No one today would be able to stand in the middle of the road and gossip as these men are doing.

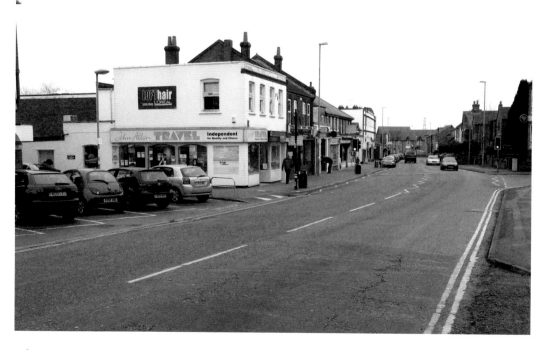

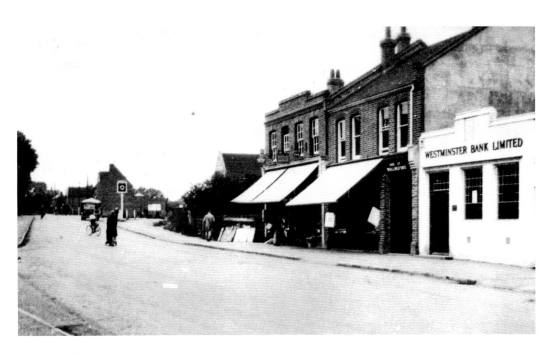

Broadway, c. 1930

Westminster Bank opened its doors to customers in 1928. The bank, like Lloyds, came to Didcot in the late nineteenth century, and both transferred to Broadway in the 1920s and 1930s. Barclays was a late arrival. Looking down the road, the shop on the west corner of Station Road had yet to be built, which happened in 1936 – its first occupant was Boots. The building in the middle foreground (below) is the old post office, dating to 1939. The two shops in the immediate foreground are still there, though they no longer sell tobacco or bread. The bank, too, is unchanged; it now deals with new customers.

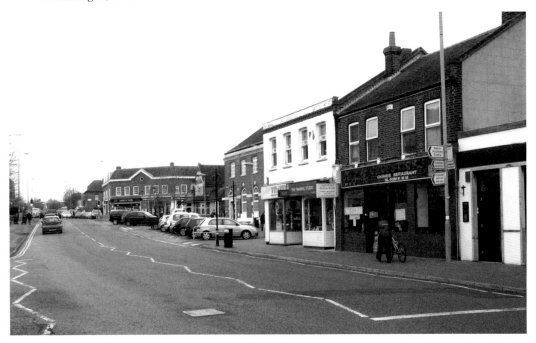

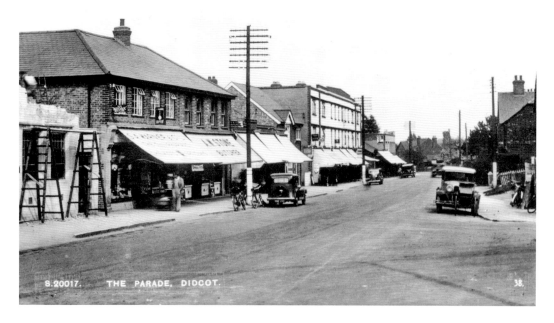

Broadway, c. 1935

The parade is Pengilleys Parade, and is the large building in the middle foreground. It consists of seven shops and dates to 1930. The two other shops sited next to the bank were Warners the chemist's and Stone the butcher's; both were built earlier in 1928. Nearly all the shops running up to the modern car parks date from this period. Today, there is really no change from that time, other than the indiscriminate car parking – you could park where you liked then!

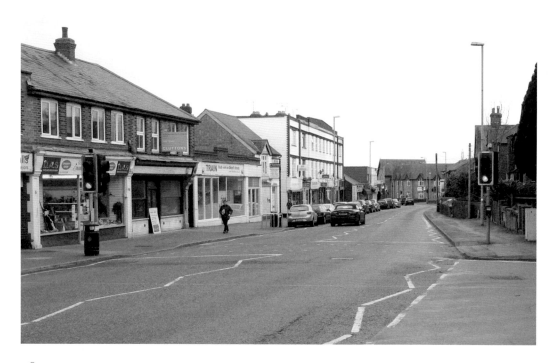

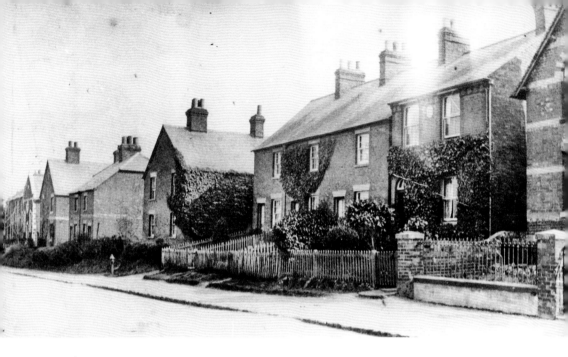

Broadway, c. 1900

Seemingly little change from that time, though some of the houses have gone, having been replaced with modern duplicates; the planning authority insisted on similar designs. Barclays Bank has taken the place of Highfield House, to the immediate right. The house on the immediate left of the bank is named Hope Cottage, of 1870.

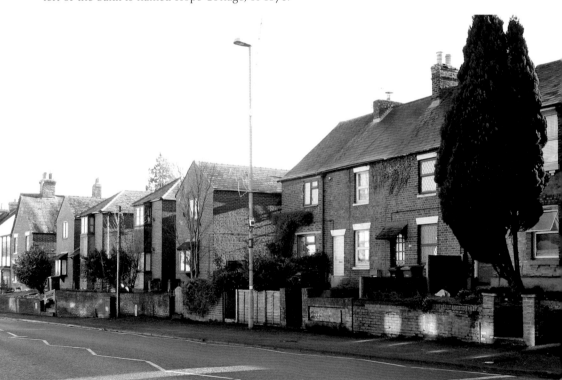

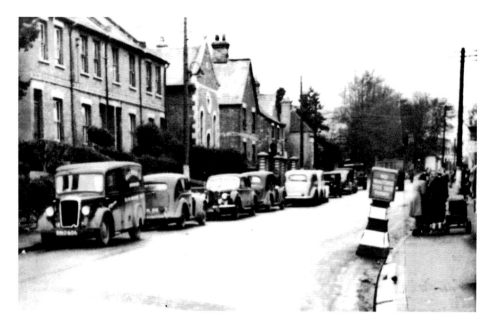

Broadway, c. 1948

The same view, but looking up rather than down; fifty years later, the motor car is far more evident. Car parking in Broadway, even just after the Second World War, became an ongoing problem for the local authorities. Berkshire County Council finally issued an order that parking was only permitted on the north side on even-numbered days for twenty minutes, and on the south side on odd-numbered days for the same amount of time. The legend on the sign reads, 'No waiting this side today'. Attempts were made to extend the time to an hour without success. Now in these enlightened days, parking is allowed for an hour at a time on the north side only.

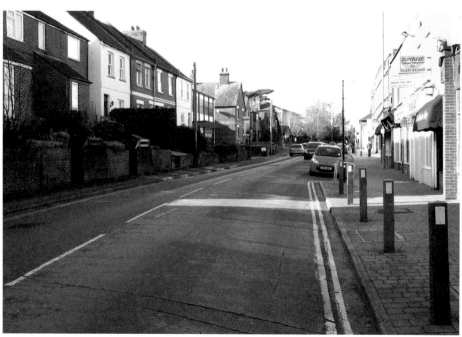

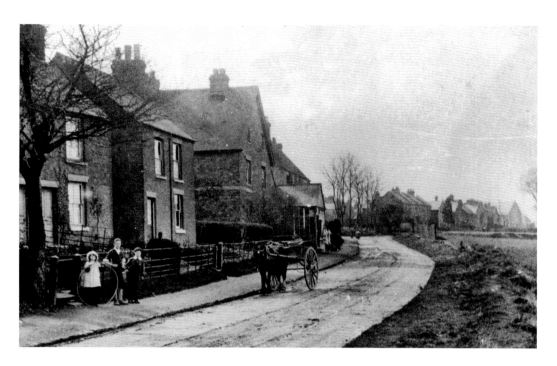

Broadway, c. 1905

Wallingford Road at the turn of the twentieth century. These houses still exist. The greatest change has taken place on the other side, where today the road is much wider. The shops standing here date from the 1950s and '60s. Farmland still fronted the road, as in the earlier photograph, as late as 1951.

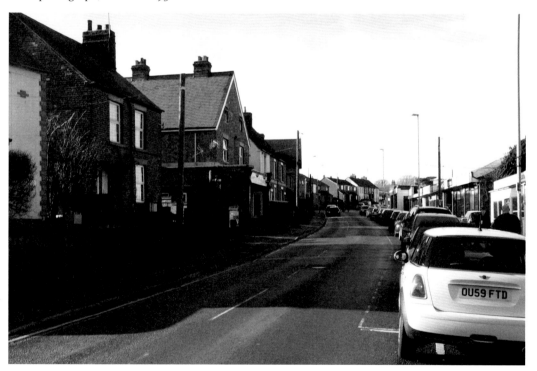

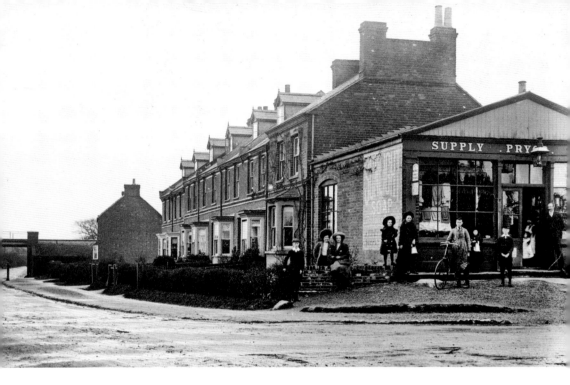

Broadway, c. 1903

John Pryor stands with his children at the door of his shop in Hagbourne Road. He sold groceries and clothing. He had moved here in 1890 from his former shop opposite the railway station. The row of terraced houses dates to 1885, and beyond is the railway bridge for the Didcot, Newbury & Southampton Railway. The house standing next to it was demolished in the 1970s, when the Fleetway housing estate was built. The very busy modern roundabout was constructed much later and is part of Hitchcock Way, the link road to the A34.

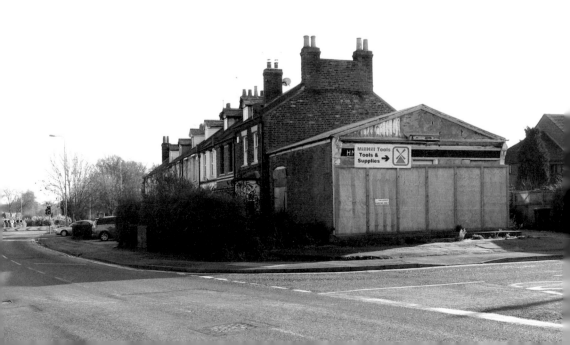

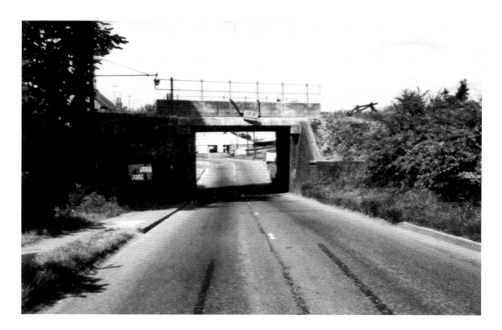

Broadway, c. 1975

This bridge was a remnant of the Didcot, Newbury & Southampton Railway, which was closed in 1964 as part of the rationalisation of British Railways, as set out by Dr Beeching in his report of 1963. The bridge, like Marsh Bridge, was a hindrance to the commercial development of Didcot in the 1950s and '60s, as large vehicles were unable to access the town because the low height of these bridges, which were designed for a horse and cart. Despite attempts to have the bridge demolished, neither British Rail nor Berkshire County Council would act because of the cost. Eventually, in the mid-1970s, Blakes the building firm, demolished it as a condition of building the Fleetway housing estate. It's hard to believe that it ever existed when you see the modern roundabout that took its place.

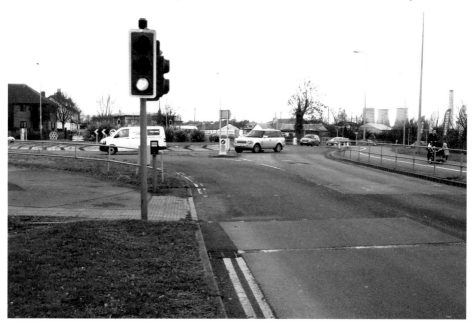

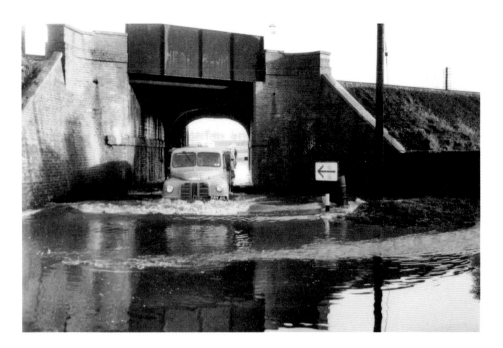

Broadway, c. 1960

The flooding of Marsh Bridge. This was a normal and frequent occurence for many drivers each time it rained heavily, in winter or at any other time. The problem was that the drains were inadequate to remove water during heavy storms. Despite pleas to Berkshire County Council, they refused to act because of the costs. Improvements were only made after 1974, when the new Oxfordshire County Council became the highway authority. Eventually, it was replaced by a new railway bridge, funded partly by Tesco as a condition of the planning permission given to the supermarket giant for their new store. The new bridge opened in June 1996 and took over two years to build.

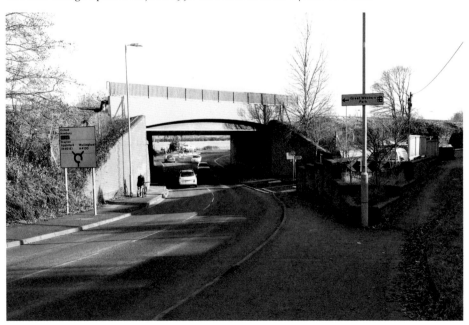

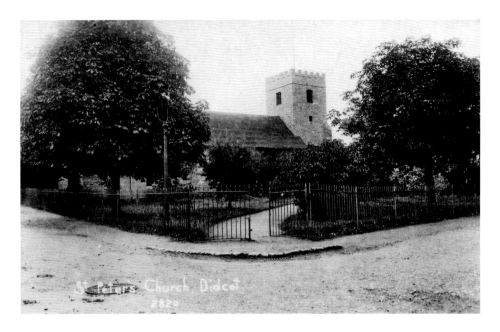

The Former St Peter's Church, Church Street, *c.* 1915

The old church closed after the new St Peter's, in Newlands Avenue, was consecrated in 1977. This earlier church had previously been erected in 1891, due in part to the generosity of Robert Rich, a wealthy landowner of the time. He was also a feared magistrate, sitting at Wallingford. In time it became too small, especially as the congregation had to travel from further afield, so it was decided that a new church was needed. It took nearly thirty years before it came to fruition. The old church building still exists, serving the community in a different way. It is now the Northbourne Centre.

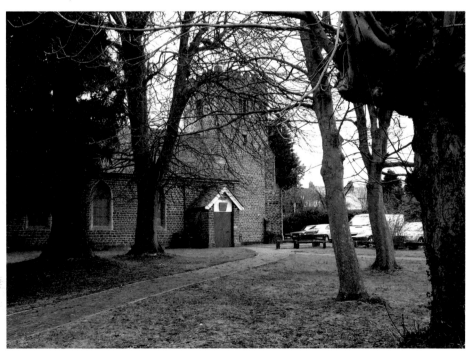

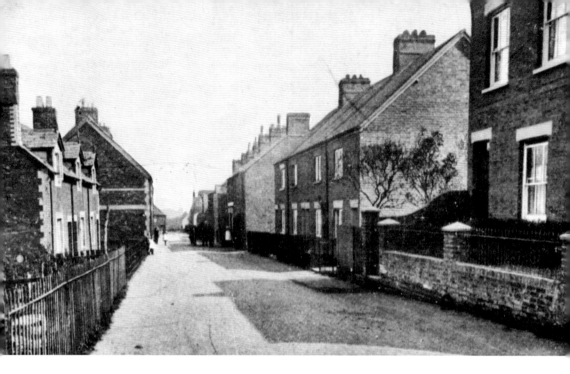

Church Street, c. 1905

Most of the houses in this road were erected in the late nineteenth century by a small number of speculative builders for rent – hence the different styles. The houses seen here were built between 1869 and 1903. The road is very narrow, as anyone who lives there will tell you, and was even more so when first laid down in 1869, being half the width of today. The need for pavements made it even narrower.

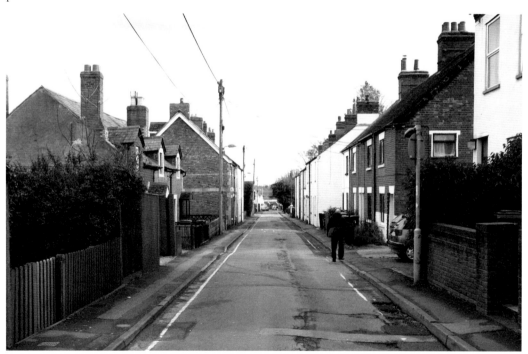

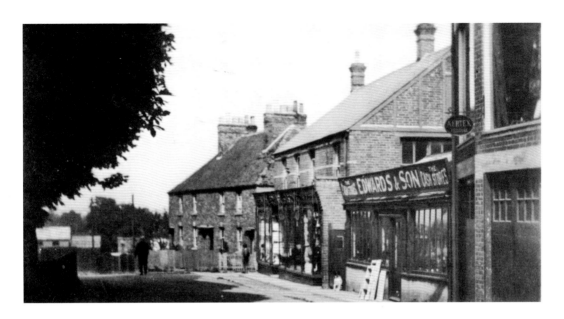

Edwards' Shop, High Street, 1929

This was an ironmonger's and clothing shop, and was run until the 1980s by Aubrey Dale. When he retired he sold the business to an insurance firm, which was a great loss to the town. The business had first been established by the Edwards family in the late nineteenth century in a house dating to 1870. The shop passed from the Edwards family to the Taylors, who sold it to Aubrey Dale's parents in 1933, and he continued trading after their death. Part of the shop has been demolished, and the row of terraced houses was built in its place.

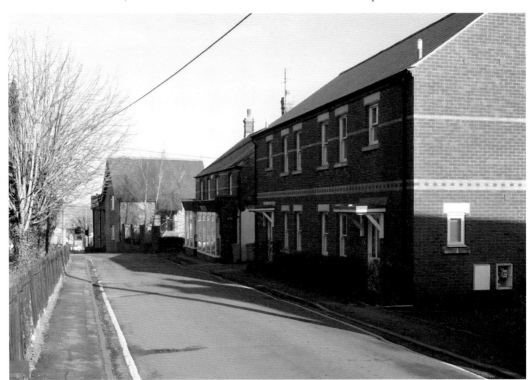

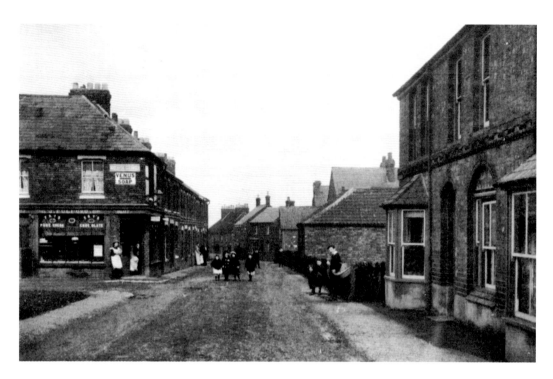

High Street, *c.* 1900

The shop on the left is one of the many corner shops throughout the town that has had to close since 1980, suffering competition from the shops on Broadway. In the 1970s, it was Livings Bakery. The shop originally opened in 1881, and at the time of this photograph, it was run by John Fulford and his wife as a general store. John was a prominent liberal at the time. Mrs Fulford also had a butcher's shop, sited next to Edwards' shop. There were over six shops trading in Northbourne during the late nineteenth century – there was even a toy shop that lasted for more than twenty years. It was a very prosperous community.

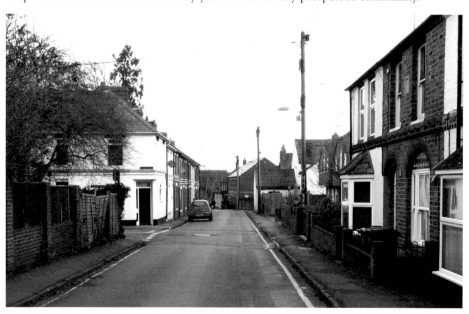

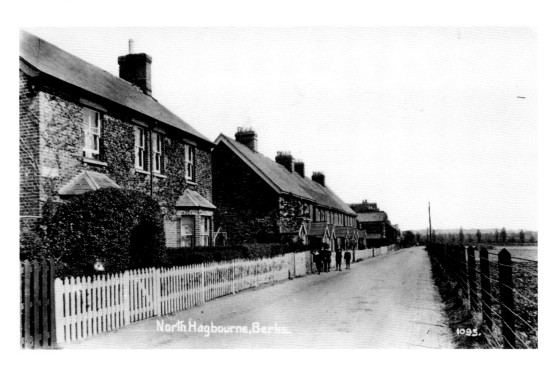

North Hagbourne, Berks.

Wessex Road, c. 1905

Wessex Road, or rather South Street, as it was named at that time. The change to Wessex Road came in 1929 as part of the rationalisation of Didcot road names. The second terrace of houses on the left was cleared away as part of a slum clearance programme in the 1970s and new flats have taken their place.

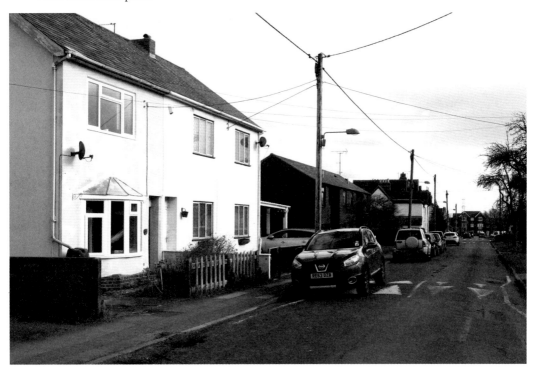

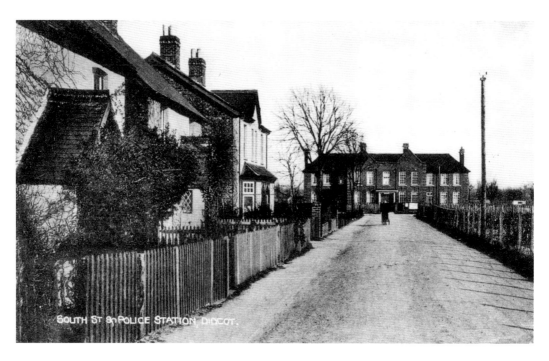

Wessex Road, *c*. 1915

South Street again, but further down the road heading towards the old police station in Hagbourne Road. The modern houses and bungalows on the south side of Wessex Road were built many years after the date of this postcard, taking the place of the farmland that existed then.

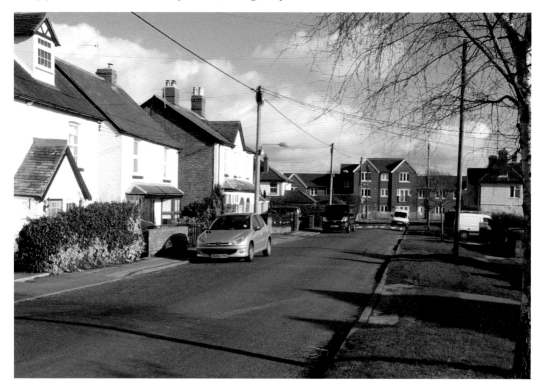

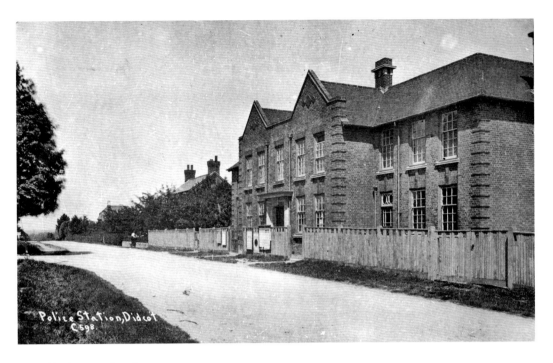

Hagbourne Road, *c.* 1915

Didcot's original police station, built in 1912. It continued in that role until the 1960s, when it was replaced by the new police station in Mereland Road, opening in 1969. After this time, the earlier building became Didcot Parish Council's offices, before passing to the county council, who used it a halfway house for homeless people. It has since been demolished and these flats built in its place.

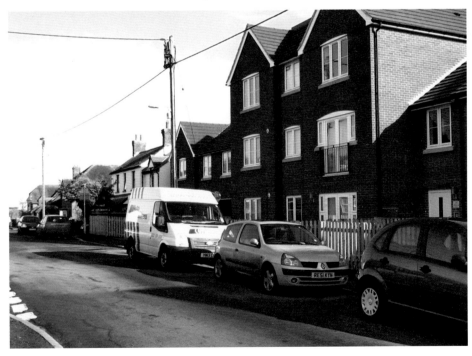

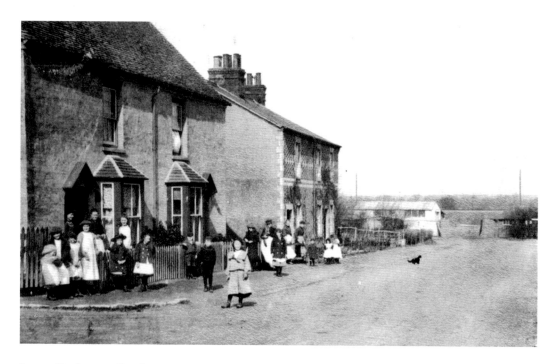

Lower Hagbourne Road, *c.* **1900**

This scene comes from one of the earliest series of postcards of Didcot ever produced, and is by Warland Andrews of Abingdon. It probably dates to the late 1890s. It is of the lower part of Hagbourne Road and the houses shown here are still there – both were built in the early 1870s. In the early days of photography, a photographer attracted wide attention, and often gathered people together, in this case children, to give his photographs depth and extra interest.

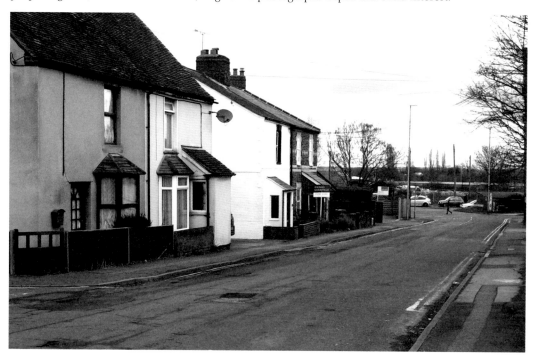

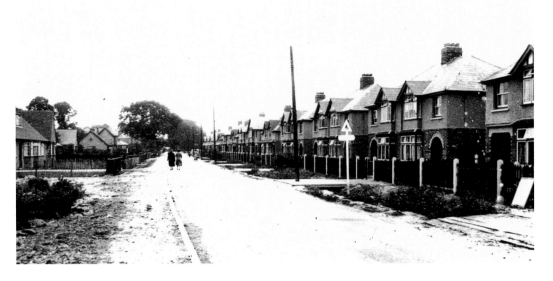

Park Road, _c._ 1936

When this photograph was taken, the houses on the right had just been built by a company owned by A. J. Colbourne, the Public Works Construction Company of Swindon. There have been changes – then there were very few cars, allowing the women in the distance to walk in the road without fear of being run down!

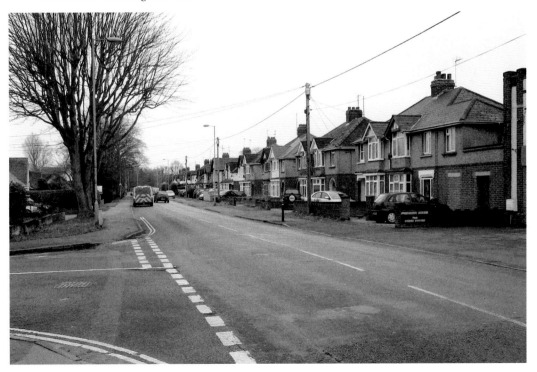

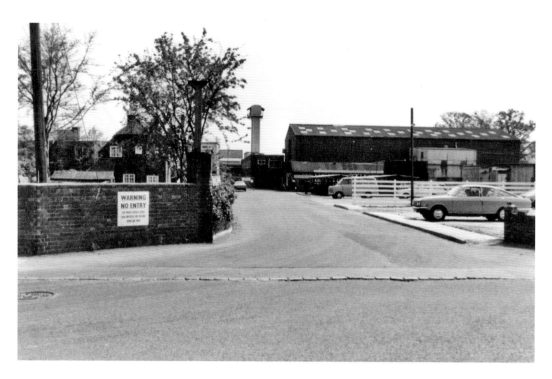

Park Road, Samor's Food Factory, 1974

Samor's cannery factory was formerly sited in Park Road. Its name is an amalgam of the names of the first two owners, Samson and Morphew. It opened in 1933 against strong local opposition, both from locals and the parish council. The local authority of the time allowed it to be built because there was a strong need for jobs, especially for women. The factory continued trading. It was owned by Heinz, then Premier Foods, until the 1990s, when it was sold for housing. The Samor Way housing estate now occupies its former site.

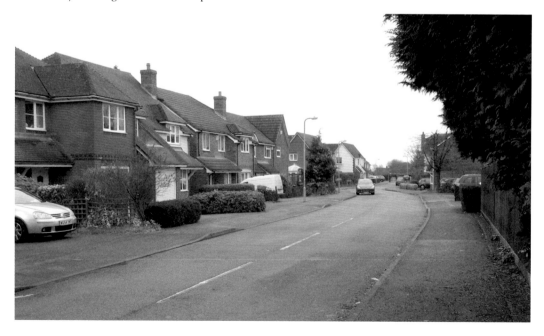

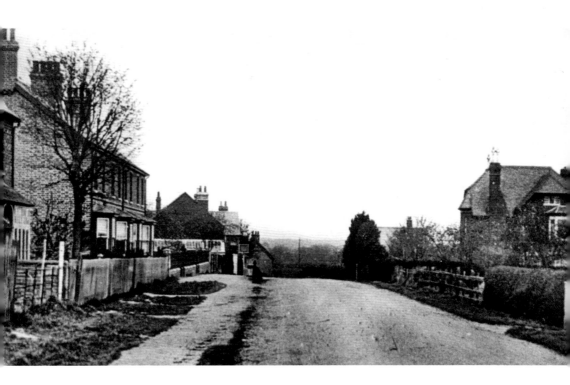

Hagbourne Road, c. 1910

A tranquil scene pictured at a time, when Northbourne enjoyed the peace of the Edwardian era prior to the outbreak of the First World War. Looking north towards the railway and Rich's Sidings, the houses to the left of the road dates back to the 1870s. The pub (whose sign can just be seen) is now the The Sprat, but was originally called The Railway Arms. It first opened its doors in 1880. The large house on the right, still colloquially known as 'The Busby Guest House', has been a dental surgery for twenty years or more. The road is now congested with parked cars.

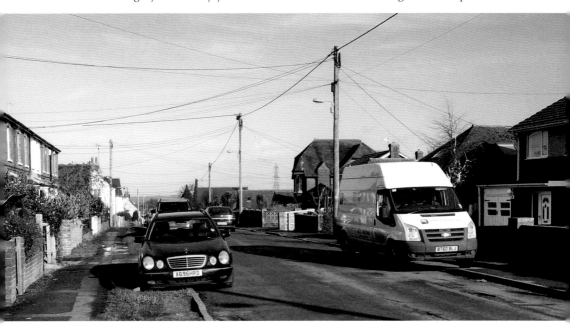

Acknowledgements

I would like to take this opportunity to thank Don Farnborough, whose kindness and unstinting help in allowing me to borrow and copy from his large collection of Didcot postcards has always been of great help to me. Many of the images reproduced in this book have come from this source. The remaining pictures are from my own collection. I also thank Miss Josie Midwinter for allowing me to reproduce the photograph of her family's shop at the railway station. Lastly, I would like to thank my wife, for her help in editing and correcting the text in this book.